The Richter Interviews

Hans Ulrich Obrist

D1610866

The Richter Interviews

Hans
Ulrich
Obrist

HENI Publishing

This publication gathers, for the very first time, the extended conversations that I have conducted with Gerhard Richter over the last twenty-six years. I was only seventeen years old when I first encountered this seminal artist, in 1986, at the opening of his exhibition *Bilder 1963–1986* at the Kunsthalle Bern. My first visit to his studio was the same year and our dialogue has continued ever since. The rhythms and movements of our evolving conversation can be mapped through the various projects, subjects and far-reaching ideas that Richter has explored throughout his career. I continue to visit him around five times a year, usually at his studio – previously in an old factory building on Bismarckstrasse in Cologne, now Osterriethweg in Hahnwald, south Cologne – yet there are only seven interviews in existence.

My inaugural interview with Richter in 1993 – entitled here 'The Impossibility of Absolute Painting' – attempted the impossible task of covering everything, including the artist's inspirations, his mentors, the beginning of his catalogue raisonné, his unrealised projects and much more. It was also around this time that I began editing his collected writings, *The Daily Practice of Painting: Writings and Interviews 1962–1993*, first published in 1995, in which this interview is featured.

Key events mark subsequent interviews. 'A Still Picture' took place in 1995 during the planning of a project I curated for the museum in progress – a space where artists conceive projects in unexpected situations, such as on billboards or aboard aeroplanes – for which Richter projected the painting *River* on to the facade of the Kunsthalle Vienna. 'Like Bright Dust and Fog', meanwhile, was conducted in the run-up to the unveiling of Richter's *Cage* paintings at the Venice Biennale in 2007.

What is fascinating about the development of the interviews is their connectedness, how one conversation leads to another. Religion is one example of a recurring theme and one which is discussed at length in the 2007 interview 'Nothing Works Without Faith'. The focus of this conversation was *Cologne Cathedral Window*, the extraordinary site-specific stained glass window for Cologne Cathedral installed the same year. An intention in the recordings was also, however, to talk about subjects that had not been covered in previous interviews. It was this impulse that led to 'The Shape of the House', an interview from 2005 on the relationship between art and architecture in Richter's thinking; whilst 'A Distorted Form of Legibility', reflects on his artist's books and Overpainted Photographs in 2011.

The last recorded conversation, 'Grey in Several Layers' took place in 2014, when I curated a monographic exhibition of Richter's work at the

Fondation Beyeler in Switzerland. The exhibition encompassed the major periods in Richter's career since 1966, and featured painting, sculpture and Overpainted Photographs. The interview focussed on series, cycles and interior spaces – also themes of the exhibition.

As I write this text, a new project and subsequent conversation are in development, the former opening at The Shed in New York City in 2019. A collaboration between Richter and the composer Steve Reich, the exhibition will draw upon both artists' interest in seriality. The continuous evolution of Richter's thinking, and thus the subjects of our conversations, is marked by major exhibitions and projects such as this. After thirty-three years of friendship and discussion, it is clear that our conversations have, in many ways, only just begun.

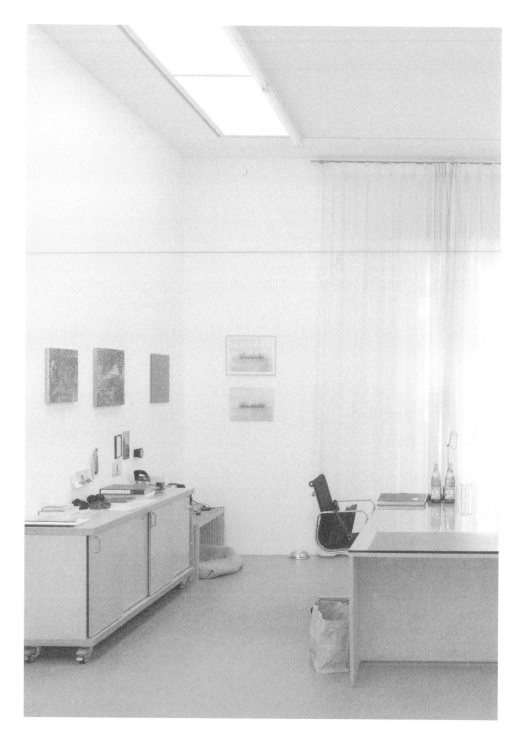

'The Impossibility of Absolute Painting' was the first recorded interview between Hans Ulrich Obrist and Gerhard Richter, conducted at Richter's studio in Cologne in 1993. In the interview, Obrist and Richter attempt to cover a wide range of subjects including Richter's inspirations, the evolution of his practice, unrealised projects and more. The interview was first published in *The Daily Practice of Painting: Writings and Interviews 1962–1993.*[1]

OBRIST Let's begin with your Notes from 1962,[2] which you were not sure if we include in the book [*Gerhard Richter: Text*]. It begins like this: 'The first impulse towards painting... stems from the need to communicate.'

RICHTER That's certainly not wrong, but it's a bit of a truism.

In the same text, you dissociate yourself firmly from the idea of 'art for art's sake'. Against that you emphasise the idea of content – not imposed content, but also not content infiltrated through the back door, of the kind you hear of nowadays.

That was an idea that was current in East Germany in the 1950s, a kind of ritual abuse of decadent, bourgeois art. Somehow or other, I had managed to internalise the idea that art can't be for art's sake but has to be about communication; I later said the same thing in a different way.

The repetitions between one text and another bring out certain basic structures in your thinking, such as your aversion to ideologies.

That's probably innate. By the age of sixteen or seventeen, I was absolutely clear that there is no God – an alarming discovery to me, after my Christian upbringing. By that time, my fundamental aversion to all beliefs and ideologies was fully developed.

This runs like a scarlet thread, as it were, through all the texts.

But on the other hand, there is also the knowledge that we *need* belief – which I sometimes refer to as a mania, an illusion that we need in order to survive or to do anything, a prime mover. And at the same time, there is this vulgar materialist view that we do not essentially differ from the animals, that there is no such thing as freedom or free will. This doesn't directly come out in the texts, but those convictions were established very early on.

That sounds fatalistic.

So it may, but the important thing for me is that this kind of fatalism or negativism and pessimism is a useful strategy in life; there is a highly positive side to it, because one has fewer illusions.

Hopeless, or inescapable?

Either will do, to make us feel better, to make us create hope.

So hope is another scarlet thread?

Hope is something I always have. And the less we deceive ourselves, the more pessimistically and fatalistically we see a thing, without kidding ourselves that we have free will, or that it is possible to move a pencil from left to right by our own autonomous decision, the more we shall succeed in not succumbing to false faiths.

The press invitation to the *Demonstration for Capitalist Realism*[3] makes it clear that this was a unique event, a Happening.

And not the inauguration of an art movement.

More of a parody of all 'isms'.

Perhaps.

Why wasn't [Sigmar] Polke there?

Purely by chance. Maybe we had temporarily fallen out at that time; but then, this demonstration was never meant to be all that important. We just wanted to do a little exhibition.

In the course of your conversations and texts, the word 'ready-made' turns up again and again, especially from Benjamin Buchloh, but also in more recent notes and interviews in which you speak of your Abstract Paintings as readymades – which is taking things as far as [Marcel] Duchamp's statement that the readymade concept expands to include the entire universe.

I do believe in the readymade in this overriding sense, because if you confine it to art alone it tends to turn glib and illustrative: *Base of the World*[4] was one example of that.

Besides the *Demonstration for Capitalist Realism*, were there other, similar projects of the same kind that never came off?

Any amount of them. In Paris, on the roof of the Galeries Lafayette, we wanted to put up a photograph of the Alps, with a cut-out for the skyline, so that Paris could have its own Alps. And there are some lovely views in the Neandertal area [near Dusseldorf]; we wanted to take people out there in buses and announce: 'Here is our art.' Later, others did just that.

On the one hand, there was this ubiquitous reference to Pop art: existing and available images were taken out of context, appropriated and recombined. But on the other hand, the *Demonstration* also reveals a connection with Happenings and Actionism.

That's what fascinated me most, at that time. For instance, we were obsessed with the idea of holding an exhibition of Roy Lichtenstein paintings, all of which we would paint ourselves. But that turned out to be too much work.

This scepticism about the ideas of the authorship and genius has led to a number of attempts to deconstruct the modernist claim to originality and authorship, by simply appropriating someone else's work without permission.

A terrible cop-out. Especially when a person builds his whole life on it. To do it once, as a demonstration, that I can understand.

In your response to Pop art at that time, were you already distancing yourself from it, or were you involved in adopting or appropriating it as a movement?

My distancing was mostly about Good and Bad; the idea or the programme didn't interest me for long anyway. And nothing has changed, really. I always thought that some were bad and some not very good, and the best were [Andy] Warhol, [Roy] Lichtenstein and [Claes] Oldenburg. And that's the way it still is.

The *Demonstration for Capitalist Realism* was an exercise in brinkmanship: it came close to a point where art dissolves into its social or political context, so that convergence must take the form of either a disappearance or a clash. And as to contextual convergence: the Happening took place in a furniture store, and it left the existing display unchanged. Art converged with a pre-existent context, but it was never about art dissolving into the context of life.

Yes, we were rather playing with fire – to find out just how far we could go with the destruction of art. But in principle I never had the remotest desire to allow painting or art to dissolve into anything else. That kind of radicalism made no sense to me at all, though radicalism was generally regarded as the be-all and end-all at that time.

As a criterion of quality?

No, art was the most important quality. That's why I then made fun of it all in the Polke/Richter text for Hanover,[5] and said that I was conventional and loved Raphael and beautiful paintings.

Were you then conscious of these distinct positions?

Yes, of course I was, and sometimes I had a guilty conscience about not being quite radical enough.

Not even in the *Demonstration for Capitalist Realism*?

When you're doing a thing like that, you tend to get high on it and just do it. But then, when you're making something of your own again, or thinking over how terrifically radical other people are – Jackson Pollock's drip paintings, or Carl Andre's metal plates, or Arman with his containers, now that was regarded as radical. And I've never seen myself that way; I've always painted.

In spite of your constant dialogue and exchange of information with Polke and [Konrad] Fischer, the mechanisms of group bonding were never formalised, as they were for instance in Art & Language.[6]

That was quite deliberate. There were rare and exceptional moments when we were doing a thing together and forming a kind of impromptu community; the rest of the time we were competing with each other.

There's this text lifted from a newspaper, on a poster for Galerie Friedrich & Dahlem.[7]

Now that was a readymade, wasn't it?

Your only textual readymade known to me, except for the *Perry Rhodan*[8] composite in the Galerie h catalogue and your non-statement in the book by [Wulf] Herzogenrath.[9]

To me it was just the same as a found photograph. But I don't think anyone twigged, because it was on the poster and just disappeared. Later, I often tried out texts or text montages of the same kind.

How did the *Perry Rhodan* text collage come about?

We'd read the stuff, and it fitted into the utopian naivety of the 1960s, with all those ideas about other planets. This unartistic, popular quality, it all went together with photographs, magazines, glossies; that was the Pop side of it. All completely unimaginable today.

Another absurdist text is Polke's imaginary Richter/Thwaites interview.[10] The term 'Pop painter' turns up in that. Was it meant ironically, or did you all then define yourselves as the German representatives of Pop art?

It was meant ironically; at that point we were trying to keep our distance from Pop. It was only at the very beginning that we were naive enough to go off with Konrad Fischer and do the rounds of the galleries, Sonnabend and Iris Clert, and announce: 'We are the German Pop artists.'

But the use of existing images and texts did come from the influence of Pop, which freed available, popular images from their contexts and saw them in a new way as pictures in new combinations.

Yes, of course, but maybe that can also be seen as the time-honoured practice of taking something over, setting it in a new context, and so forth. Nothing new, really.

In your texts and interviews the word 'Informel' turns up repeatedly. You don't categorically reject it, but you draw a clear line of demarcation between Informel and realism. At the same time, your work is a kind of reaction against the then-dominant stylistic and manneristic games of the Informel and Tachist school, which arose from automatism — and the term 'Informel' stands for the exploitation of that potential. What does the word 'Informel' mean to you today?

As I see it, all of them — Tachists, Action painters, Informel artists and the rest — are only part of an Informel movement that covers a lot of other things as well. I think there's an Informel element in [Josef] Beuys; but it all began with Duchamp and chance, or with [Piet] Mondrian, or with the Impressionists. The Informel is the opposite of the constructional quality of classicism — the age of kings, of clearly formed hierarchies.

So in that context you still see yourself as an Informel artist?

Yes, in principle. The age of the Informel has hardly begun yet.

And this landscape here?

This is Informel, in spite of all the structure, which has rather a nostalgic look to it.

Although there's no leading idea, no leitmotif, there's no uncontrolled use of chance either. In your pictures, chance never takes the decisions; at most, chance asks the questions.

15

It's the found object, which you then accept, alter, or even destroy – but always control. The process of generating the chance event can be as planned and deliberate as you like.

In the same Notes [1962], you talk about the photographs everyone takes, and their function as cult objects. The banal source images reveal an unexpected, lasting, universal pictorial quality. When you said that, were you exploring the possible legitimisation of illegitimate pictures – an 'illegitimate art', as [Pierre] Bourdieu calls it?

The legitimate pictures are the photographs – the devotional pictures that people hang or set up in their homes. We then sometimes use them for art, and that may well be illegitimate.

You also say in the same text that a photograph can be seen as a picture, outside the categories of high and low, ritual photography and art. This is an important difference between you and Polke, isn't it, your refusal to go in for darkroom manipulations?

That's more of a technical, formal point; it's not that significant. I just don't like being in darkrooms. But to go back to legitimisation: perhaps it's also illegitimate to bring the snapshot form too close to the readymade. Photographs are only readymades because they're so easy to produce, by comparison with painstakingly hand-painted pictures; as with a ready-made, you only have to select them. The whole distinction is rather a shaky one anyway, because it may well turn out that there are no such things as readymades at all. There are only pictures, which have value to many people or to very few, which remain interesting for a very long time or only for a few seconds, and for which very little or a very great deal is paid.

So the people who take the snaps are artists...

Yes, and when I then paint another picture of *Uncle Rudi*, the little officer, I'm actually watering down the true work of art achieved by those two or three private individuals who put Rudi behind glass and stood him on the sideboard or hung him on the wall. The only sense in which I'm not watering it down is that by painting the thing I am giving it rather more universality.

The displacement makes it exemplary.

Yes, and blurring was the only way of getting this done quickly. The Photo-Realists later painted photographs in a finicky, detailed way. I haven't the patience for that; and then there are the distracting perceptual factors that find their way in. One is the outsize format, and the other is admiration

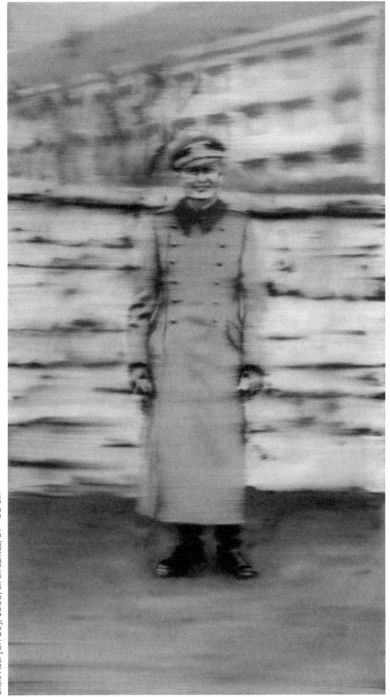

Uncle Rudi [CR 85], 1965, oil on canvas, 87 × 50 cm

of the labour involved: the fact that it takes a whole year, the response of marvelling at the way it looks 'just like a photo'. I wanted to avoid all that by cheapening the production values. You can see that a photograph is meant, but it hasn't been laboriously copied and duplicated. This worked, and the pictures had the basic resemblance to photography without looking like copies of photographs.

> You talk elsewhere about photography as drawing – or as the camera obscura, which Vermeer used – in the sense of a pre-liminary stage in the production of a picture. This reverses the primacy of photography, which is supposed to have given rise to modernism by breaking down barriers. You simply use the photograph in making the picture, as a matter of course.

In the traditional practice of painting, that's the first step. In the past, painters went out into the open air and sketched. We take snaps. It's also meant to counter the tendency to take photography too seriously, all that 'second-hand world' stuff,[11] which is wholly unimportant to me. Many critics thought that my art was a critique of contemporary life: criticising it for being cut off from direct experience. But that was never what I meant.

> The camera crops an image. It doesn't give the one, absolute image. The selected, partial image pushes forward and simultaneously recedes.

It's often been said that my pictures look like details. That may be so, but I can't understand it, probably because I take it too much for granted already. But maybe it was meant to refer to a certain inconclusive, open-ended quality: pictures that are cropped on four sides but can never show anything but sections, details.

> And each time just one of the many possibilities.

There are exceptions, of course, where it isn't one of the many possibilities at all – as in the *Betty* portrait or the *Ema* nude.

> And the burnt-out house [*House*, 1992].

Maybe the house, too. Those works tend towards the masterpiece, and if they aren't masterpieces it's just because I know that that just won't do: it's only ever like a quotation of a masterpiece, perhaps. But in principle everything is a detail.

> In *Betty* and *Ema* the masterpiece status just seems to creep in; I was also thinking of *Cathedral Corner* from 1987 [p.78].

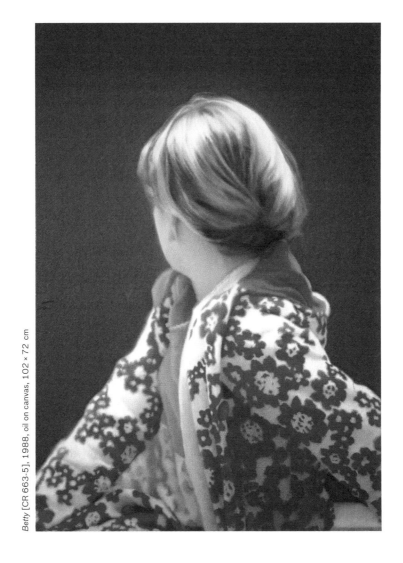

Betty [CR 663-5], 1988, oil on canvas, 102 × 72 cm

But it can also happen with a Grey Picture. On a museum wall, there's something masterpiece-like about it; the way it's hung.

And the other Abstract Paintings?

I might include pictures like *Janus* and *Juno*, for instance. But maybe only because they have such beautiful titles. There are some.

Such as *S.D.* or *Ozu*. The masterpiece is the utter antithesis of the anecdote. And of the detail, and of the sequence. On the one hand,

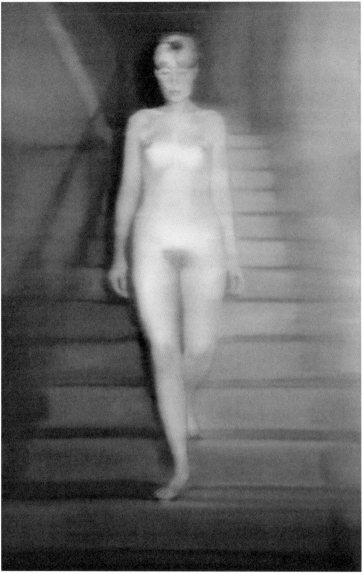

Ema (Nude on a Staircase) [CR 134], 1966, oil on canvas, 200 × 130 cm

you talk about the impossibility of absolute painting; on the other,
you bring back the concept of the masterpiece.

Perhaps that's what one is always striving for, the masterpiece; it's just that
it never is one. The masterpiece seems so far outside time that one can't
even strive to attain it.

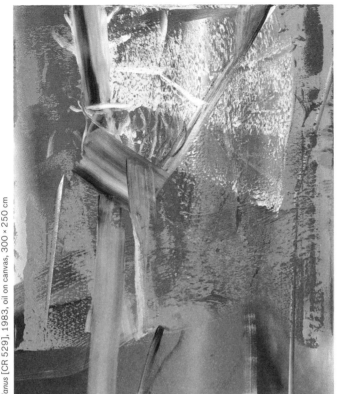

Janus [CR 529], 1983, oil on canvas, 300 × 250 cm

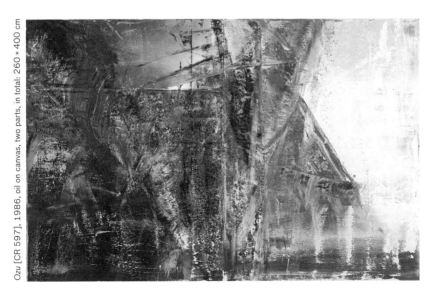

Ozu [CR 597], 1986, oil on canvas, two parts, in total: 260 × 400 cm

There's not much of either quality in Van Gogh's *Sunflowers*. In that case, it's 'The Vincent van Gogh Story' that seems to be most important. And the whole masterpiece debate is relativised by the fact that the pictures we now regard as masterpieces may well have been the perfectly ordinary consumer art of their own day.

The *Mona Lisa* had its aura, even in Leonardo's lifetime. That kind of premonition of the enduring quality of a work is a well-known phenomenon.

But at that time the word 'master' itself had a different meaning, which had far more to do with craftsmanship.

In London, the *Betty* portrait suddenly had an enduring, universal, almost absolute quality; and curiously enough, the same thing applied to the wider response that it got as a poster on the Underground. The masterpiece always implies this movement; you say it and then you take it back. It is one, and at the same time it isn't.

It's slightly refracted by the historicist or nostalgic effect.

The discussion of works and artists' positions, which are important to you, comes to a head in the Buchloh interview,[12] with a kind of reconstruction of your view of the history of art. In a much earlier interview, you mentioned principally Barnett Newman, as representative of a historical position, and Gilbert & George as contemporaries.

Barnett Newman was always important. He came to me straight after Mondrian and Pollock. Newman was an ideal, because he created these big, clear, sublime fields that I could never have managed. He was my complete opposite.

Did your kinship with Gilbert & George lie in a shared interest and wish for normality at that time: the idea of disappearing into a completely banal life?

I liked them as outsiders, above all. At the same time, Minimal, Land and Conceptual art were dominant. I valued all that, though I had very little to do with it. With Gilbert & George, too, I liked the very nostalgic side. They were the first people who liked my landscapes. I think what impressed me the most was the way they took their own independence as a matter of course.

Not forcing pictures into the dogmatic modernist straitjacket?

The ideological straitjacket. Perhaps I have a kind of immunity to ideologies and fashions, because movements have always passed me by: the piety of my parents' house, the Nazi period, Socialism, Rock – and all the other fashions that made up the zeitgeist in thought, attitudes, dress, haircuts and all the rest. To me it all seemed intimidating rather than attractive.

It's a surprise that you never mention [René] Magritte.

He's too popular, too pretty for me. Wonderful calendar art; village school-master's art. 'This is not a pipe': to me, that's just not a very important piece of information.

What seems important to me is his recurrent doubt as to the names of things.

Perhaps it got excluded because I could already see that I was in danger of painting something a bit too popular. I notice that at exhibitions: I get a very good reaction. The doormen and cleaning ladies think it's all great, even the Abstract Paintings. It's actually the ideal state of affairs, if you do something that everyone likes.

The modernist rejection of any 'Art for All' sprang from a feeling of resentment, because painting had lost all its representational functions to photography. The ease with which you use photography puts the boot on the other foot – though without reviving the old unity between observer and object, or reverting to direct experience of the object. The construction of the picture now appears in a shattered mirror.

The image of the artist as a misunderstood figure is abhorrent to me. I much prefer the high times, as in the Renaissance or in Egypt, where art was part of the social order and was needed in the present. The suffering, unappreciated Van Gogh is not my ideal.

And his pictures?

I like [Gustave] Courbet's better.

Mainly as a phenomenon and as a person. When I first saw the work, I wasn't all that interested; it was too eccentric for me. I'm increasingly in favour of the official, the classic, the universal.

Along with [Édouard] Manet and [Jean-Auguste-Dominique] Ingres, Beuys is the only other artist who hangs in your studio.

Because he still fascinates me as a person more than anyone else; that special aura of his is something I've never come across either before or since. The rest are all far more ordinary. Lichtenstein and Warhol I can take in at a glance; they never had the dangerous quality that Beuys had.

In connection with the Abstract Paintings of the 1980s, you bring the idea of chance into play once again. [John] Cage made chance operations out of methods based on uncertainty. But I never see the chance in your work in terms of his interpretation of chance operations; you have less of the serial juggling with known elements, governed by the throw of a dice, that was usual in Conceptual art.

Except for the Colour Charts. Those were serial; I mixed the given colours and then placed them according to chance. I found it interesting to tie chance to a wholly rigid order.

That means giving it a form.

An architect once asked me what was so good about the Colour Charts; what was supposed to be the art in them. I tried to explain to him that it had cost me a great deal of work to develop the right proportions and give it the right look.

To give it a form, in other words.

Yes, because there would have been other possible ways of realising the idea. I could paint these biscuits here in different colours and throw them across the room, and then I would have 1,024 colours in a chance form. Or in the Grey Pictures: if I had painted those because I couldn't think of anything else and because it was all meaningless anyway, then I might just as well have tipped out the paint on the street, or done nothing at all.

The later Abstract Paintings also evoke the idea of the picture as a 'model'. Is that meant in a Mondrian-like sense?

This was something that came up in an interview with Buchloh: the idea that Mondrian's paintings might be understood as social models of a

non-hierarchical, egalitarian world. Perhaps that was what prompted me to see my own Abstract Paintings as models, not of an egalitarian world but of a varied and constantly changing one. But fortunately, Mondrian's paintings are not read as models of society. Their most important quality is a very different one. It would be terrible if the *Broadway Boogie Woogie* painting were a model of society: there would be the Yellows, the Reds and the Blues, all moving ahead in straight lines.

> Roland Barthes says, 'To be modern is to know what is no longer possible.'

What is no longer possible is everything that has already been said, and all the attendant stupidities of substance and form, pseudo-intelligent messages and dishonest intentions. If you try to avoid all that, it's hard at first, but eventually it works.

> This avoidance is something you once described as 'escape'; and in your earlier pictures this referred mainly to the choice of motifs.

Like Beuys's hare. He was always on the run, too. How shall I put it? Escaping from falsehood is always a good starting point.

> It seems to me that this idea of escape is always cropping up in the present-day world. It's an escape that faces the facts – neither a nostalgic escape into the past, nor a utopian escape into the future.

I hope so. Although it does create more uncertainty because the utopian or nostalgic escapees are always the ones who have the advantage of knowing where they're going.

> Uncertainty as the diametrical opposite of the controlled working plan?

Basically, yes: though the whole thing may seem fairly professional, it isn't, because it's not planned and controlled: it just happens.

> [James McNeill] Whistler's 'Art happens'.

Or [Daniel] Buren's 'It paints'.

> In your *Atlas*, there are sketches and designs for rooms that reveal an effort to find a place to fit the pictures, to create a kind of place-specific quality.

25

That sort of thing only works in sketches, because the execution would be unendurable, overblown and bombastic. But it was good to design sanctuaries of that kind, for pictures with an incredible total effect.

Utopian spaces?

And megalomaniac ones.

The *Two Sculptures for a Room by Palermo*,[13] now in the Lenbachhaus in Munich, create a state of permanence without reference to the actual location.

It's a very modest thing.

What works of yours exist in public space? The Underground station in Duisburg;[14] the Hypo-Bank in Dusseldorf?[15]

And *Victoria*, two large-format works in an insurance company. The two yellow *Strokes* [pp.40–1] are in a school. That's all, almost. And at BMW [in Munich], rather badly hung, there are three large canvases: *Red*, *Yellow*, *Blue* [p.55], each one three metres high by six metres wide – as an enlargement.

Commissioned works...

Yes, sometimes I've enjoyed doing commissioned work, in order to discover something that I wouldn't have found of my own accord. And so, when Siemens commissioned my first Townscape,[16] that led to all the Townscapes that followed. It's also very nice when pictures have a known place to go to.

You've always made it a point of principle not to control where your pictures go, not to decide where and how they are hung. No reliance on your own hall of fame or private museum. You've just let the pictures go.

Let them go unconditionally. They need no precautions. If they're any good, they'll always find the right place; if they're not, they'll end up in the basement, and quite right too.

Hans Haacke, for instance, tries to get this total control. He has been trying to strengthen the artist's position.

Just imagine [Alberto] Giacometti making stipulations of that kind! I'm glad he didn't, so that his sculptures can be shown differently each time: now in Denmark, now in Stuttgart. Every time they look different, and yet they always stay the same. There are some frightful instances of artists who have

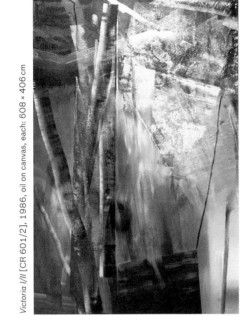
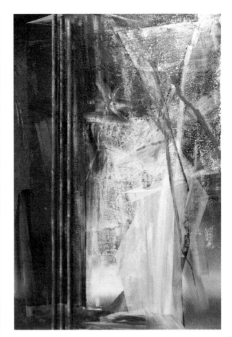

Victoria I/II [CR 601/2], 1986, oil on canvas, each: 608 × 406 cm

created these imperishable monuments for themselves. A certain Herr [Karl Wilhelm] Diefenbach, for instance, on Capri.[17] Embarrassing.

> There are some positive examples: the Segantini Museum, the Rothko Chapel, Walter De Maria's *The New York Earth Room*.

And [De Maria's] *The Lightning Field*. And all those beautiful churches, of course – there it has worked wonderfully well.

> The pictures have lasted through time, thanks to their symbiotic relationship with the space.

We're a long way away from that at the moment. Jannis Kounellis, in that curious conversation he had with Beuys, Kiefer and Cucchi,[18] talked about building a cathedral. Simulated presence. It's sometimes done for reasons of art politics, when galleries and curators want to force something through and set up artificial monuments of that kind, full of pseudo-masterpieces.

> The 'New Museology' of the 1980s arose from the so-called 'Beaubourg Effect',[19] which also had its political side. Individual works from a wide-ranging collection serve to illustrate the

chronological charts; the display is designed for the masses, and only stops short of the final logical step, which would be to replace the originals with copies...

Pity.

In view of this combination of haste and cultural illiteracy, it seems to me more important than ever that there are some places where one can go and pay a visit to works – the way I visit your Baader-Meinhof work in Frankfurt from time to time.

Not that that's an ideal museum, exactly. But I know what you mean.

When I saw your room in Kassel,[20] I wondered at first whether the wood was chosen by you, whether it was taking up something that is implicit in the pavilion architecture. The wood might be part of a prefabricated kit, and it ironically forces the whole thing almost down to the level of a near domestic interior. At the same time, it strongly emphasises the break with the 'white cube' formula.

It was the architect Paul Robbrecht who suggested the wood panelling. The obligatory white wall dates back only sixty or eighty years.

The only other place where I've seen that kind of floor-to-ceiling hanging in relation to your work is in your own studio.

It only works in small spaces, on the private side. Whenever I've tried it on a temporary partition in a big exhibition, it's never worked.

What surprised me in Kassel was the flower piece. Was that painted after your visit to Japan?[21]

Yes, perhaps that trip did have some influence: it affected those vertical scraped *Strip* paintings, too.

The flower piece has remained unique in your work. But at the time it put me in mind of a cycle. It could be a starting point.

I have tried painting photographs of flowers since then, but there's nothing suitable. And when I tried to paint the flowers themselves, that didn't work either. Unfortunately, I should have remembered that it hardly ever works for me to take a photograph in order to use it for a painting. You take a photograph for its own sake, and then later, if you're lucky, you discover it as the source of a painting. It seems to be more a matter of chance, taking

a shot with the specific quality that's worth painting. The same thing happened with the first Cathedral picture. I took the photograph in 1984. I was not in the best of moods at that time. And when I painted it, three years later, I went on to photograph some other cathedral corners of the same kind – but I didn't get one usable shot. The state of mind counts for a lot...

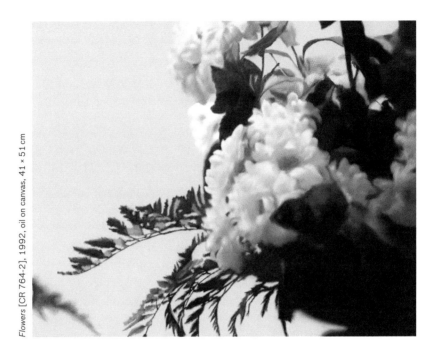

Flowers [CR 764-2], 1992, oil on canvas, 41 × 51 cm

... a state of mind that is specific to a time...

... and makes you receptive to something. If I went to that cathedral now, I wouldn't know what to photograph. There's no reason why, and I can't force it. I even went all the way to Greenland, because Caspar David Friedrich painted that beautiful picture of *The Wreck of Hope*. I took hundreds of photographs up there and barely one picture came out of it.[22] It just didn't work.

So the 'quest for the motif' has very seldom led you to a picture?

The quest for the motif is strictly for the professionals. On the other hand, when I sit down somewhere out there, more or less aimlessly and not looking for the motif, then all of a sudden the thing I've not been looking for may open up. That's good.

29

The Flowers pieces in particular raise the issue of the experiential reality of nature, which is no longer a direct experience of nature.

Because the flowers are cut and stuck into a vase...

... or because it happens via the photograph.

I think that's less important, because directly painted flowers would be no less artificial. Everything is artificial. The bunch of flowers, the photograph – it's all artificial. There's nothing new about that.

Or, to turn it round again: the Demiurge and Nietzsche's eternal recurrence of nature. The painter goes into nature and sees it as a picture created by him.

A nice idea, and one that's absolutely right, not only for painters but for everyone. We make our own nature, because we always see it in the way that suits us culturally. When we look on mountains as beautiful, although they're nothing but stupid and obstructive rock piles; or see that silly weed out there as a beautiful shrub, gently waving in the breeze: these are just our own projections, which go far beyond any practical, utilitarian values.

When did you first use mirrors?

In 1981, at the Städtische Kunsthalle in Dusseldorf.[23] Before that I designed a mirror room for Kasper König's *Westkunst* show, but it was never built. All that exists is the design – four mirrors for one room.

Sphere I was also declared to be a mirror.

It's strange about *Sphere I*, because I once said that a ball was the most ridiculous sculpture that I could imagine.

If one makes it oneself.

Perhaps even as an object, because a sphere has this idiotic perfection. I don't know why I now like it.

At the time when you made *4 Panes of Glass* in 1967, glass was being used a lot, both in art and in architecture.

In art, too?

Glass was used in Minimal and Conceptual art: [Robert] Morris had mirror cubes, in which the exhibition space and the viewer

became part of the work; and of course Dan Graham, in his 'Corporate Arcadias' text, show the strong presence of glass in the architecture of that period. In mid-1960s buildings, you watch the people on the lower floors working: it's transparent architecture.

That was a social preoccupation on Graham's part. What attracted me about my Mirrors was the idea of having nothing manipulated in them. A piece of bought mirror. Just hung there, without any addition, to

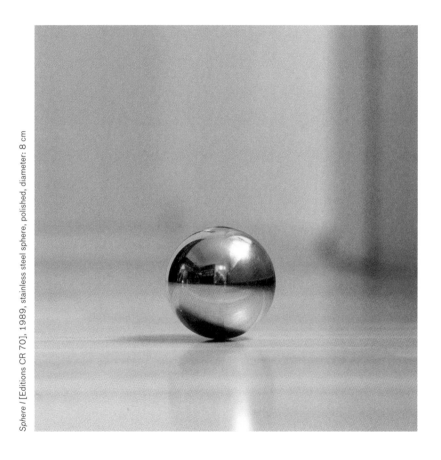

Sphere I [Editions CR 70], 1989, stainless steel sphere, polished, diameter: 8 cm

operate immediately and directly. Even at the risk of being boring. Mere demonstration. The Mirrors, and even more the *Panes of Glass*, were also certainly directed against Duchamp, against his *Large Glass*.

Duchamp comes back all the time, like a boomerang. You take up a position opposed to the complexity of the

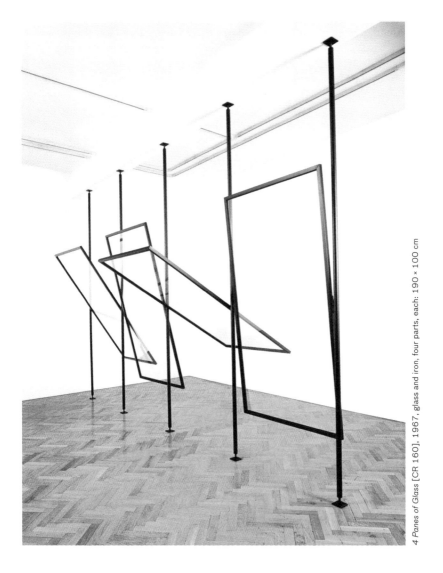

4 Panes of Glass [CR 160], 1967, glass and iron, four parts, each: 190 × 100 cm

Large Glass, and straightaway in comes the readymade idea as well.

Maybe. But what interested me was going against all that pseudo-complexity. The mystery-mongering, with dust and little lines and all sorts of other stuff on top. I don't like manufactured mystery.

In *4 Panes of Glass*, the artistic act was reduced to the most minimal level.

Once again, I had to take the trouble of finding the right proportion, getting the right framework. This is not a readymade, any more than Duchamp's *Large Glass* is.

Because so much work went into it.

That's right. At one point I nearly bought a readymade. It was a motor-driven clown doll, about 1.5 metres tall, which stood up and then collapsed into itself. It cost over 600 DM at that time, and I couldn't afford it. Sometimes I regret not having bought that clown.

You would have exhibited it just like that, as an uncorrected readymade?

Just like that. There are just a few rare cases when one regrets not having done a thing, and that's one of them. Otherwise I would have forgotten it long ago.

In your studio there's a little mirror, hung in such a way that one is always seeing bits of recently finished paintings reflected in it.

In this case, it's a good thing that it isn't head-high, but a little higher, so that you see the mirror and not the usual mirror image, which is yourself.

Over the last two years you've made the grey and coloured mirrors, which you showed in the *Mirrors* exhibition at Anthony d'Offay in London.[24]

Those are panes of glass with a layer of paint on the back. This means that they are somewhere in between, neither a real mirror nor a monochrome painting. That's what I like about them.

I see the mirror as a metaphor for your work as a whole. The word 'reflect' has two planes of meaning, which bring the viewer into the picture, and thus the viewer is in two states at once. A reflective trick.

The pleasant thing is that it makes the pictorial space even more variable and more subject to chance than it is in photography.

Even more open?

Yes, this is the only picture that always looks different. And perhaps there's an allusion somewhere to the fact that every picture is a mirror.

Making fun of the modernistic attribute of flatness.

Or rather of the view that every picture has space and significance and is an appearance and an illusion, however radical it may be, right down to the modernist goal of the flat surface, as in the Grey Pictures: these surfaces, too, have once more become illusionistic.

> The steel ball, by reflecting the pictorial space, is simultaneously both the receiver and the transmitter of appearance. Once the attribute of the Emperor's worldly power, it seems to have rolled out of the picture – partly as a rejection of naive forms of New Age holism. Lately, you've often added paint to paintings or scraped it off.

Just like playing boules. Shoot; create new situations.

1 Hans Ulrich Obrist (ed.), *The Daily Practice of Painting: Writings and Interviews 1962–1993*, (London: Thames & Hudson, 1995), pp.251–73.

2 Gerhard Richter, 'Notes, 1962' in Dietmar Elger and Hans Ulrich Obrist (eds) *Gerhard Richter Text: Writings, Interviews and Letters 1961–2007*, (London: Thames and Hudson, 2009), pp.14–15.

3 *Living with Pop – A Demonstration for Capitalist Realism* was organised by Richter, Polke and Konrad Lueg at the Berges Furniture Store in Dusseldorf on 11 October 1963. Guests were invited to view 'what is hailed in America as the greatest breakthrough in art since Cubism'. Instead they found Richter and Lueg inhabiting a staged living room, as a critique of Pop art and its appropriation of everyday objects and consumer culture.

4 *Base of the World* (1961) by Piero Manzoni, is an iron and bronze plinth that stands upside down, as if to support the Earth.

5 Gerhard Richter and Sigmar Polke, 'Text for exhibition catalogue, Galerie h, Hanover, 1966' in Obrist (ed.), *The Daily Practice of Painting*, pp.36–44.

6 Art & Language is a Conceptual art collective that was founded in 1968 in Coventry, UK.

7 Gerhard Richter, 'Poster text for the exhibition *Klasen und Richter*, Galerie Friedrich & Dahlem, Munich, 1964' in Obrist (ed.), *The Daily Practice of Painting*, p.23.

8 *Perry Rhodan* is a German science fiction comic book, first published in 1961.

9 Gerhard Richter 'Letters to Wulf Herzogenrath, 1972' in Obrist (ed.), *The Daily Practice of Painting*, pp.68–9.

10 Sigmar Polke, 'Interview between John Anthony Thwaites and Gerhard Richter, written by Sigmar Polke, October 1964' in Obrist (ed.), *The Daily Practice of Painting*, pp.24–5.

11 In a letter to two artist friends, Richter describes photographs as a 'second-hand world', i.e. one not experienced first-hand. See Ortrud Westheider and Michael Philipp, *Gerhard Richter: Images of an Era*, (Munich: Hirmer and London: HENI Publishing, 2011), p.56.

12 'Interview with Benjamin H. D. Buchloh, 1986' in Elger and Obrist (eds) in *Gerhard Richter Text: Writings, Interviews and Letters 1961–2007*, pp.163–87.

13 *Two Sculptures for a Room by Palermo* [CR 297-2] was originally installed at the Galerie Heiner Friedrich, Cologne, in 1971. It included two busts mounted on columns by Richter, alongside a mural by Palermo.

14 In 1992 Gerhard Richter and Isa Genzken created a site-specific enamel mural for the subway station Koenig-Heinrich-Platz in Duisburg, Germany.

15 *Six Mirrors for a Bank* [CR 740/741] was created for the Hypo-Bank in Dusseldorf in 1991.

16 *Cathedral Square, Milan* [CR 169] was made for Siemens, Milan, in 1968.

17 Karl Wilhelm Diefenbach (1851–1913) was a German painter. There is a museum dedicated to his work on the Italian island of Capri.

18 A conversation between Joseph Beuys, Jannis Kounellis, Anselm Kiefer and Enzo Cucchi was held in 1985 at the library of the Basel Kunsthalle. It was later published in Jacqueline Burckhardt (ed.), *Ein Gesprach/Una Discussione*, (Zurich: Parkett-Verlag, 1986).

19 Jean Baudrillard posited that cultural institutions, such as the Pompidou in the Beaubourg area of Paris, have such a strong influence that they ultimately destroy that which they aim to preserve, by dictating Western ideologies on the world. He named this 'The Beaubourg Effect'.

20 At documenta 9 (13 June to 20 September 1992), Richter exhibited, in a wood-panelled room, eleven Abstract Paintings, *XL 513* [CR 20–1], *Grey Mirror* [CR 765] and *Flowers* [CR 764–2].

21 Richter embarked on a two-week trip to Japan on 16 September 1991, with the intention of finding material for a film version of *Atlas*. The film was never completed.

22 Richter visited Greenland in 1972. Many of his photographs from the trip were integrated into his *Atlas*. The artist's book *Eis* [Editions CR 58] compiles 213 of these photographs.

23 *Georg Baselitz – Gerhard Richter*, 30 May to 5 July 1981.

24 *Gerhard Richter: Mirrors*, Anthony d'Offay, 22 April to 17 June 1991. Several Abstract Paintings and numerous *Mirror* works by Richter were exhibited.

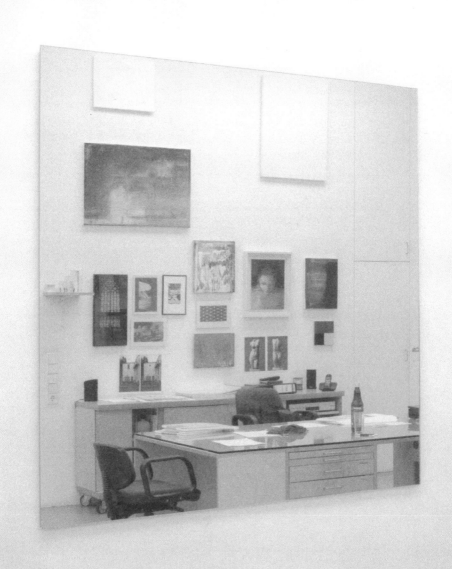

'A Still Picture' was conducted on 15 September 1995 at Gerhard Richter's studio, to coincide with a project for the museum in progress, curated by Obrist. The museum in progress is a space where artists conceive projects in unexpected situations, such as on billboards, in newspapers or aboard aeroplanes. From December 1995 to March 1996 Richter projected his painting *River* on to the facade of the Kunsthalle Vienna at a size of 10 by 54 metres. The idea was to create a connection between the building, the flow of traffic that passed by the Kunsthalle and the river running underneath. The interview was first published on the museum in progress website[1] and takes as its focus the purpose and form of a picture.

RICHTER We begin simply. [*laughs*]

The blow-up and the game with the ruler are a thread running through your work. I'm thinking, for instance, of the sketches in *Atlas* where pictures were intended to become large-format Abstract Paintings a little later.

That's right, that happened more often.

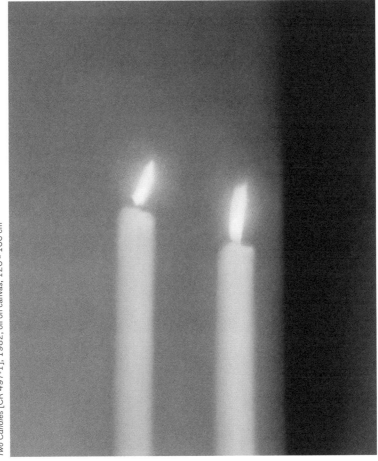

Two Candles [CR 497-1], 1982, oil on canvas, 120 × 100 cm

39

I don't even know anymore who in Dresden had the idea of asking for a picture from me to cover the large facade. I think it was Dr Schmidt from the museum, and he was also the one who suggested the candle as a motif. I then made collages of various pictures of candles on a photo of the facade and that's how I settled on what seemed the most suitable motif of the two candles. At first it was only intended to look pretty, but later a politically useful statement was also found in the picture.

How did the picture become politically charged?

That came about through the 13 February anniversary of the destruction of Dresden fifty years earlier, which was coming up. And candles had always been an important symbol for the GDR, as a silent protest against the regime, which already made a great impression. Naturally, it was a strange feeling to see that a small picture of candles was turning into something completely different, something that I had never intended. Because as I was painting it, it neither had this unequivocal meaning nor was it intended to be anything like a street picture. It sort of ran away from me and became something over which I no longer had control. A similar thing happened with the Vienna Kunsthalle picture.

Talking about pictures running away...

Like with children who later do things that you don't understand any more.

There's this 'two-leg theory'. The works are present in highly specialised discursive contexts, while simultaneously having a popular dimension.

I wasn't previously aware of that, that a picture appears in a whole range of forms that I am absolutely not, or only seldom, responsible for. That's done by other people, and because they do it for another purpose, it also becomes another picture to drive past. I neither made nor intended either of them. A nice side-effect. To make them popular.

The form in which the same picture appears is changed by the selection of details, by the enlargement, as well as by the copying by CALSI [computer-aided large-scale imagery]. The translation is permanently there in your pictures; the translation from photo to picture, which is once again reproduced. The large-format picture [50 by 10 metres] brings to mind the propaganda pictures of the Russian Revolution – for instance, those by Nathan Altman – or Raoul Dufy's *Fée Electricité*. Or your own monumental *Stroke* paintings.

Except that with Dufy it's not a reproduction; he himself painted it directly on the wall. And my two large lines weren't an enlargement of pictures but of designs that I had made only for this purpose. On the other hand, the picture for the Vienna Kunsthalle is a reproduction, and on top of that it's a reproduction of the detail from a picture. So it became a completely new picture, and also because its authorship is a completely different one. It wasn't even me who had the idea, that came from others, and the choice of the motif was then made collectively, so it wasn't from me alone. That's

Stroke (on Blue) [CR 451], 1979, oil on canvas, four parts, in total: 190 × 2000 cm
Stroke (on Red) [CR 452], 1980, oil on canvas, four parts, in total: 190 × 2000 cm

41

a completely different way of working, rather like in an advertising agency, where I have just been working on a long-term project. That's very exciting and very contemporary. Maybe exhibitions would even be organised much better and with much more effect on the public with reproductions instead of originals.

The writer Bruce Sterling has been putting his books on the internet for several years and making them available to everyone. What is astounding is that the sales figures for his hardcovers and paperbacks have in no way sunk but have risen dramatically. In the virtual and digital world, there's a great demand for the book as an object that can be handled. The same applies to exhibitions: the originals don't become any less valuable, but the distribution is much greater.

That's good – that's the only thing you should really want; to be as broadly present as possible. To expand oneself. Otherwise the others will do it. [*laughs*]

Are there limits? Television?

Only because it doesn't know what to do with pictures. They only want actors, the artist in the talkshow, who then makes himself totally ridiculous.

And a still picture on television?

That would be wonderful – occasionally a still picture on a box, without commentary, without music; maybe it would be a release for the viewers.

Robert Bresson said that different rules are valid in each medium. In this connection, maybe it would be interesting to talk about your film experiment in Japan.[3]

Where I went about it in the wrong way, rather carelessly experimented in another medium. That went completely wrong. Film is not for me.

That brings us back to your original reservations about the large-format picture.

At the beginning I thought that I had to come up with something very special – not what I can do but something completely different, something spectacular, screaming or funny. Then I have a lot of silly ideas which in the end only depress me. That's why your idea of using the river picture was very healthy. And that only a detail was enlarged I find very beautiful: it also fits in with the plan for the small book, which will show only details.

The Halifax book was multi-perspective and gathered various views of a picture.[4] *In contrast, the book now being put together [Gerhard Richter: Abstract Painting 825-11. 69 Details] will include frontally reproduced details of a picture. Going back to the large-format picture, at first you thought of a blow-up of a sequence of photos.*

Yes, but as I said, of very special photos, which I can't even create. Now I can also imagine my photos in such a large format. Next time.

1 www.mip.at/attachments/127

2 In 1995 a reproduction of *Two Candles* [CR 497-1] was projected on to the facade of the Dresden Kunstverein, to commemorate the 50th anniversary of the bombing of Dresden during the Second World War.

3 Richter visited Japan in 1991 with the intention of making a film version of *Atlas*. The film was never completed.

4 *Halifax: 128 details from a Picture* features the photographs that comprise the artwork *128 Photographs from a Painting* [CR 441]. Each photograph is a detail of *Abstract Painting* [CR 432–5] and together reproduces the artwork in full.

The Impossibility of
Absolute Painting
1993

A Still Picture
1995

The Shape of
the House
2005

Nothing Works
Without Faith
2007

Like Bright Dust
and Fog
2007

A Distorted Form
of Legibility
2011

Grey in Several
Layers
2014

'The Shape of the House' addresses Richter's long-held fascination with architecture and its relationship to his practice. The interview was conducted in November 2005 at Richter's studio on Osterriethweg in Hahnwald, south Cologne, and was first published in *Domus*.[1]

Going through the many interviews that you have given, I noticed that the topic of architecture is almost never mentioned, which is strange because architecture has played a central role in your exhibitions, and you have had many conversations with architects over the years. And then there is also the architecture of your house, which you designed yourself. I was wondering why the subject of architecture almost never comes up in your interviews.

RICHTER Architecture was, or is, a kind of hobby, an inclination I have to fiddling around and building things. Putting up shelves or cupboards, or making tools, or designing houses... it always has a functional or social motivation. If social changes are in the air, I am gripped immediately by the desire to build, and I think that I accelerate or anticipate changes in my life by doing so, at least in draft. In the case of my house, that was anticipation: in other words, first build, then change one's life.

In other words, it helped to trigger a change...

Yes, first came the house, and then came the family, and the house was filled.

Could it be that the house produces reality?

[*laughs*] Yes, with this house I anticipated my vague desire for new social conditions. And the shape of the house was directed in a rather naive, polemical fashion against the dissolution of architecture. That is to say, it was altogether conservative: symmetrical, clearly structured, robust.

Against the then-prevalent deconstructivism?

Yes, and that hasn't got any less crazy to this day.

So it was a reaction against...

... all this wild stuff. Sure, I realise the dangers of an austere position in architecture, such as is represented by [Oswald Mathias] Ungers. And there are other brilliant architects like Norman Foster and Renzo Piano, for example. But when I saw [Piano's] Zentrum Paul Klee in Bern, which looks like a hall for equestrian sports, I thought it was simply dreadful. It has nothing to do with Klee; it could be filled with anything at all. There is probably a patron in Bern who wants to throw his money down the drain. It's terrible to leave everything to the architect. Basically, it's the client's fault – they

no longer know what they want. Anyone will go over the top if they have no limits to keep to.

Yet one counter-example that immediately comes to my mind is the new building for the Walker Art Center in Minneapolis.[2] In this case, a brilliant client brought forth remarkable architecture. The museum as an amplifier. But in the case of your house, it was a very different situation, because you weren't the architect's client; you sketched the house, and became the architect yourself. You had an architect, but he only played an advisory role.

I had built a number of models. For the details and for the total implementation, I certainly needed an architect to show me what things looked like, what I was looking for. That's the difference between me and Wittgenstein, who designed everything down to the last rod and screw. I have no inclination whatever to succumb to this extreme form of building mania.

So you made the drawings, the ground plan, and designed the structure?

Everything, every room and the whole archaic ground plan, the cross and the square wings, this splendid symmetry, and if I'm lucky, the result will be a piece of timelessness.

I'd be interested to know if there were architects who were important for you, who influenced or inspired you?

No particular architects. Rather, I had a general interest in buildings, irrespective of when or by whom. Of course there are names, [Andrea] Palladio, the Bauhaus architects and [Oswald Mathias] Ungers... everything that looked good.

Mies [van der Rohe]?

Yes

[Walter] Gropius? Le Corbusier?

Gropius, yes. Corbusier is a bit too round and colourful for me.

You've been friends with Ungers for a long time.

I've always liked Ungers. In the 1980s, he designed the architecture for the *Westkunst* exhibition organised by Kasper König, which I liked

48

very much. There were numerous assaults against his display. But I've always said how much I liked it, which helped Ungers. Since then, there's been a link between us... but the fact that we get on so well has a human side, too.

Are you interested in the work of Herzog & de Meuron?

I used to be, but today I think the dissolution has gone too far. Yet, when I think how critical I was about the Gehry museum in Bilbao, I have to admit that, although I didn't think much of it when I went there, I was fascinated and it made me think.

Time and again, artists have turned their hand to architecture. That also has something to do with the interest in light. History comes up with various examples of the idea of the artist's studio. Joan Miró, for example, had a studio built for him in Mallorca by Josep Lluís Sert, the exponent of Spanish modernism. How must a room function if it's to be of any use to you as a studio?

Better than the one I have now. But somehow I'd be frightened of having a perfect studio: I'd rather have one as defective as it is.

How did you find the documenta room that Paul Robbrecht designed for your pictures in 1992?

I liked it very much. It worked very well as an exhibition space. But I wouldn't like a studio like that.

The room was clad in wood.

That was good, and that's why I've done my office like that.

In your place, the high doors are striking.

Yes, they're three metres high; I like that. No one is made to look small with a door like this. On the contrary, they look taller. It may sound paradoxical, because with my 1.7 metres I would fit almost twice over.

Another feature of your house is that it opens towards the inside, while being closed off towards the outside. It is almost invisible from the road...

Maybe these days I'd be less concerned to close myself off like this, but this district here in Hahnwald [on the outskirts of Cologne] was

already a bit difficult for me. I gradually had to get used to having such strange neighbours.

So it was a question of sealing yourself off?

Yes, of seclusion, of not being disturbed. The house itself is open all round. It took me a year to notice that you can't live here without an alarm system, that with twelve external doors on the ground floor, more or less unsecured, you could be butchered and no one would notice. That's something I changed root and branch.

Another aspect of your relationship to architecture is, of course, with your exhibitions. Very often, for your paintings, you have designed rooms completely. You have many drawings of these displays.

Sometimes they're utopian, but they are always for real rooms, in order to stage the exhibition properly and to present the pictures as well as possible.

When did this actually begin? There are utopian room configurations at a very early stage, even with *Atlas* in the 1960s.[3]

That's when it began. It's simply one of my inclinations – to want to have beautiful rooms. In many cases, I insisted on the room having a window. For example, in 1986 in the Kunsthalle Dusseldorf, the first thing I did was have a window unblocked.

You were also the first to come to grips with the very problematical room situation in the Deutsche Guggenheim in Berlin, and you did it by opening a window to the street.

That was part of the work, so to speak. It was time-consuming to unblock the windows, and because of the angle of the panes of glass it was also expensive. Now, in Dusseldorf, at the exhibition in the Kunstsammlung Nordrhein-Westfalen,[4] I have integrated windows into the room once more, so that you can see in from the outside and above all, so that you can see out from the inside.

Is this the window as a 'display feature'?

I don't know what that means, but I think it's a bad thing that museums no longer want to have any windows at all, if possible. The buildings are all so air-conditioned and equipped with such sterile lighting that no windows are needed any more.

Sketches (for Sculptures Palermo – Richter) [Atlas Sheet 262], 1971, ink on paper, 66.7 × 51.7 cm

51

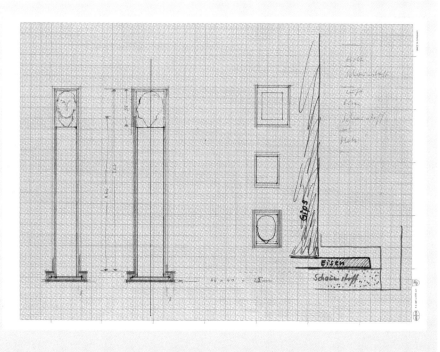

Sketches (for Sculptures Palermo – Richter) [Atlas Sheet 263], 1971, ink on paper, 66.7 × 51.7 cm

Like this underground situation in the Lenbachhaus in Munich, where your Dusseldorf exhibition is currently touring.

I was very unhappy about that. In fact, it made me ill to think about it. That's not architecture, that's a station platform, it's un-architecture. A proper play needs a stage, and pictures need architecture. It's quite simple.

There's also an interesting drawing that you made of a museum for the 1,000 Grey Pictures, a barracks with 1,000 rooms [p.153]. One picture per room. This mutual relationship between the picture and the room is very important for you. And then there is the room that you did with Blinky Palermo in the early 1970s. How did that come about?

I found his murals very good, and when I once went into the gallery in Munich where he just had painted the walls ochre, I said, more as a joke, 'Something's missing; maybe next time we should set up two sculptures.' And that's just what we did in Heiner Friedrich's gallery in Cologne.

Another example is your joint exhibition in the Galerie Ernst in Hanover.

Oh yes, the exhibition *For Salvador Dalí* with Palermo in Hanover: only two pictures by me and all around, beneath the ceiling, the black stripe by him – highly staged, pretty good.

Although you did that for Salvador Dalí, didn't you?

Yes, out of conviction. Although, or because, Dalí was, for modern painters, the one with the worst reputation, a reactionary bourgeois kitschmonger. We wanted to do something to counter this opinion.

But Dalí is not an artist you really admire.

No. Palermo didn't particularly like him either. But we also realised that he was a brilliant painter, who had painted wonderful, crazy paintings. In this sense, an undifferentiated negative judgement is entirely inappropriate, in fact blind.

In contrast to the previous project with Palermo, which became a permanent room, and now functions in the Lenbachhaus like a little chapel, this Dalí room was only temporary. Could it be reconstructed?

I could still imagine that, albeit not really without Palermo. It wasn't even possible to reconstruct it in the Lenbachhaus in Munich. All that's left are

the two sculptures, and with the typical ochre the whole thing recalls Palermo; it is therefore more in the way of a homage to him.

> By you to him?

By me and the Lenbachhaus.

> In terms of exhibition displays and architecture, another interesting aspect is your work with mirrors and glass panels, which is also something that begins in the 1960s with the rooms. They're a continually recurring element. And in recent years you have also done these piled-up glasses...

You mean the eleven panels of glass leaning against the wall? Well, after the framed panels, which I had properly planned and designed, the leaning panels are more of a gift. That is to say, I found them here in my studio. The glazier had leant them against the wall. And they were left there till I discovered them.

> A readymade, so to speak...

So to speak. Because they were deposited in my studio for other purposes. And there weren't eleven, but five or six, and they looked better and better. It was a step-by-step process. First you get it into the right light, out of the corridor into the studio. Next the right beams (you have to try out the best number), and at some stage or other the piece is finished. At that time, I was expecting Kasper König, and I wasn't sure whether he would see these eleven panels at all. But he saw them at once and said he would like them. I was of course delighted.

> Few of your works react to rooms in the sense of a response to, or a critique of, a room.

Like for example the *Eight Grey*, which was the first installed in the Berlin Guggenheim, or the *6 Grey Mirrors* for Dia:Beacon. Although both series were conceived for a particular room, they would of course be possible in a different room.

> So, in the case of the three BMW pictures, which were commissioned exclusively for this one particular foyer, or of the twenty-metre *Strokes* [p.40–1] for the school in Soest, they would still be conceivable elsewhere, wouldn't they? And in the case of the *Black, Red, Gold* installation for the Reichstag?

Photographic Details of Colour Samples (Designs for BMW) [Atlas Sheet 103], 1973, colour photographs on card, 66.7 × 51.7 cm

Well, the flag's dimensions are too extreme for it to fit anywhere else. Quite apart from the content, for something like the *Black, Red, Gold*, the Reichstag really is the right place.

There are a number of smaller versions and editions of this flag. Interestingly, the commissioned work led in turn to other works.

I wasn't commissioned to depict the German flag. I was stimulated by the theme, even though Palermo[5] existed and that famous flag by Jasper Johns. I also once had a one by one metre version of the flag in my living room,

55

but that didn't work; it was too intrusive, having to look at this black, red and gold all the time.

> It's a constant oscillation. On the one hand, you have a flag, and on the other, you can look at it as abstract.

Yes, in Berlin the flag motif is not obtrusive, of course. And the whole depiction is so enormous there, it has so much elegance that it puts you in a good mood. [*laughs*]

> How did the BMW pictures come about? Were they commissioned, too?

I was taking photos of palette structures and paint residues, which I then greatly enlarged and painted. The commission came at just the right time, meaning when I could put to use what I was doing at the time. With *Strontium*, it was even better: I was just experimenting with pictures on that theme when I had this enquiry from Herzog & de Meuron for the de Young Museum [in San Francisco], and I was provided with precisely what the *Strontium* motif needed – perfect printing technology and this extreme dimension of more than nine by nine metres.

> Did it work only on that wall?

No, it also looked very good on another wall, for example in the K20 in Dusseldorf, maybe even better than in the de Young Museum. I know this only from a photograph, at the de Young it is disappointing, dead and empty like the photo of a model.

> In respect of architecture, we still haven't talked about the church windows. When I was here a year ago, I went out to this little chapel on the outskirts of Cologne. That wasn't a commissioned work; what you did was hang an existing photograph. How did that come about?

A friendly printer had given me a sixty-year-old photo that fascinated me greatly. It was an aerial view of the southern part of Cologne taken by the US Air Force in February 1945, with a ruined bridge and countless bomb craters.

> That's reminiscent of your Townscapes...

... because they also look as if they've been bombed to pieces. But in the photograph it was, if anything, the other way round. Because the photo itself had been through the wars, so to speak, I had it processed and retouched,

Strontium [Atlas Sheet 747], 2006, 56.2 × 73 cm

so that it looked like a brand new, immaculate photo. We made an edition of it, and this one large photo for the church.

Now you're working on another project for a church, a window for Cologne Cathedral.

Yes, that's an enormous thing. The starting point for the design is a picture, a Colour Chart dating from 1974 [p.67]. The principle is unchanged: a number of different colour tones are placed at random in a particular grid. And the window is filled up like that.

It consists of lots of little squares, like the 1974 Colour Chart.

Yes, only in a different field: it's not square, but the shape of the Gothic window. And the size of the squares is different, and the spectrum of colours is narrower.

Why is the number of colours smaller?

It is limited to seventy-two. Of course, we could have far more different coloured pieces of glass made but, for one thing, the colour tones must

be distinguishable from a distance, and for another, the scale should be balanced. In other words, if there were five hundred shades of red but only one hundred different shades of green, the whole thing would have a red cast. So we had to develop a balanced colour scale.

I also see associations with the 1,000 Grey Pictures in the 1,000 rooms [p.153]. Both are examples of *ars combinatoria*.

Oh, really? But here with *Cologne Cathedral Window* [p.77] we are talking about something quite concrete, something real and it's a very special location that carries a greater burden of history and importance than almost any other. It is all so overwhelming that any supplementation with modern art often comes across as inhibited, false, silly or kitsch. In order to avoid this danger, I have taken the place as it is: what does the cathedral look like, how is it used? And in so doing, I have avoided wanting anything special. So, no depictions of saints, no message and, in a certain sense, not even art. It was just to be a radiantly beautiful window, as good and beautiful and with as many meanings as I could make it here and now.

Illustrating nothing? Depicting nothing?

Nothing like that. Simply this very simple design, realised optimally. Of course, I wasn't able to have these ideas before the design, but at the start I had to try out all possible picture ideas, accompanied by dissatisfaction at all these useless ideas – until I then saw a reproduction of my old Colour Field pictures and was even a little frightened, because it fitted so well.

Your large-scale pictures often oscillate between micro and macro elements. You see this particularly in the *Stroke* paintings [pp.40–1], but you can also see it in respect of your details in the *War Cut* book. I wanted to ask you something else about this to and fro of micro and macro. In your Munich exhibition, the last room with the *Silicate* provided an almost autonomous zone. It was almost a room within a room: it was my favourite room in the exhibition.

Good! That all hangs together. I was fascinated by the motif, because while imaging technology in microscopes has advanced to the point where you can really see an atom, you can never see it sharp. I find that important, because it sets a limit.

You can't go any further.

One can't go any further; there's really an end point, simply because there's nothing there that can be seen. A new quality starts there. That's fascinating in itself! And as a fact, this event shows itself quite simply as lack of sharpness, as a little out-of-focus photo.

> The first 'original' came from the *Frankfurter Allgemeine Zeitung* newspaper. Is the *Frankfurter Allgemeine Zeitung* a permanent source?

[*laughs*] That's how it is with newspapers, you get used to the daily delivery of news from the world. And even though they annoy me every day, I like them.

> The *Frankfurter Allgemeine Zeitung* was also the trigger for *War Cut*. The book started as a small project: I'd invited you to Paris and you photographed a lot of details from one of your paintings there [*Abstract Painting* [CR: 648-2], 1987, at Musée d'Art Moderne de la Ville de Paris]. What followed had a lot to do with chance...

To start with, I had no idea what I was supposed to do with the photos. They lay around in the studio until the Iraq War broke out [in 2003] and I read all the reports in the newspaper.

> Then the random encounter produced a major construction.

Perhaps because the events that the newspaper articles were describing to me were just as incomprehensible as my abstract detail photos. In any case, I saw a connection.

> You spent months sticking them this way and that.

A few weeks certainly, before the final layout was there – order versus chaos, in other words. It was good.

> Maybe we could talk about the studio. Actually there is a whole exhibition of new pictures and drawings on show here.

The drawings have only just been started. But the twelve paintings are finished. Only it is difficult to say anything about them: for me they are still too fresh to understand. Do you know what is meant by stable fever? No? When horses are kept in the stable for too long before a race, they run better. That was doubtless the case with me when making this series.

Then it went quite quickly?

Well, a few months. And now I would not know what else to do with them. They seem to be finished and maybe not too bad.

The smaller picture here shows the Twin Towers?

Yes. Probably 9/11 bothered me more than I expected. The big drawings also have something to do with that theme; maybe at the time so did all the pictures, even if you can't see that now.

On 9/11 you were on the way to your last New York exhibition when the aeroplane was forced to land in Halifax. Now there's the next New York exhibition. These twelve pictures are among the darkest of your Abstract Paintings.

Apart from the elegant *November*, *December* and *January* from 1989, which have more black. The new pictures here are more spontaneous, more abrasive, less aesthetic, somewhat painful. The little picture of the two towers was very colourful to start with, with the garish explosion

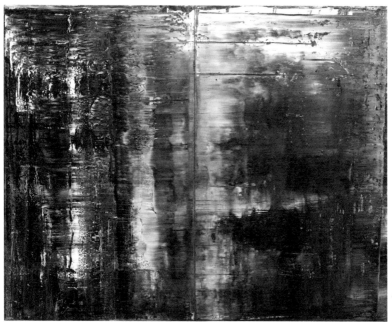

November [CR 701], 1989, oil on canvas, two parts, each panel: 320 × 200 cm

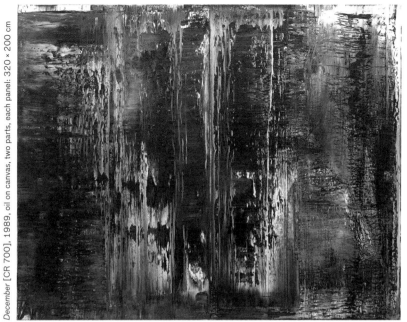

December [CR 700], 1989, oil on canvas, two parts, each panel: 320 × 200 cm

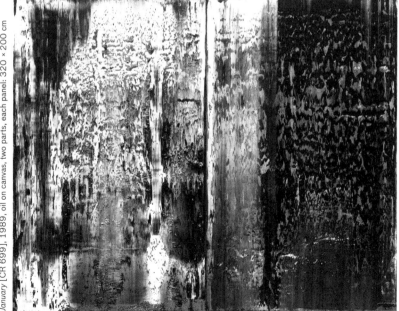

January [CR 699], 1989, oil on canvas, two parts, each panel: 320 × 200 cm

61

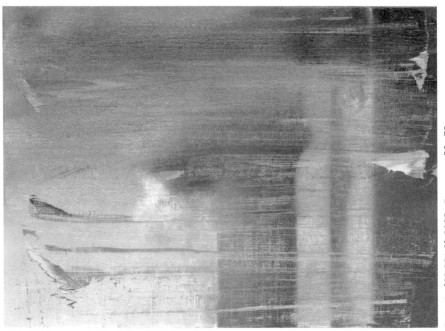

September [CR 891-5], 2005, oil on canvas, 52 × 72 cm

beneath the wonderful blue sky and the flying rubble. That couldn't work; only when I destroyed it, so to speak, scratched it off, was it fit to be seen.

> As a drawing it was already hanging here a year ago. So it was at the same time the first and the last drawing.

Yes. But I'm worried about exhibiting it. On the one hand, it's a perfectly harmless picture, small, and not at all sensational. On the other, it has such a spectacular title, *September*, and is clearly about 9/11. I should keep it, and if it still looks all right, maybe I'll exhibit it one day later on.

> Finally, are there any unfinished or unrealised projects that you would like to see completed?

Build some new houses. Realise something of the utopias that we dreamt up some forty years ago, practical things like traffic systems in the Ruhr, nice social housing on the Rhine meadows in Oberkassel [in Dusseldorf].

> Have you designed any social housing?

Some pretty wooden models, dilettante, but with a deep conviction that the world can and must be made better.

You did realise your own house!

I could imagine how it might be improved.

What changes would you make?

I'd change the location, raise the level of the plot a bit. Make the house a bit more practical, and build the four wings a metre longer – not seven metres long, but eight. That would be better – for stairs, too. And then of course a much better studio.

1 First published in *Domus*, January 2007, pp.117–25.

2 The new building at the Walker Art Center in Minneapolis was designed by Edward Larrabee Barnes and opended in 1971. In 2005 Swiss architects Herzog and de Meuron designed an extension which included a gallery, restaurant and shop.

3 *Atlas* is an ongoing collection of photographs, newspaper cuttings and sketches that Richter has assembled since the mid-1960s.

4 *Gerhard Richter*, Kunstsammlung Nordrhein-Westfalen, Dusseldorf, 12 February to 16 May 2005.

5 Blinky Palermo (1943–1977) was a German abstract painter whose work was primarily interested in form and colour. His *Metal Pictures*, 1972, are thought to reference the German flag with their grid format and blocks of colour.

The Impossibility of Absolute Painting
1993

A Still Picture
1995

The Shape of the House
2005

Nothing Works Without Faith
2007

Like Bright Dust and Fog
2007

A Distorted Form of Legibility
2011

Grey in Several Layers
2014

'Nothing Works Without Faith' was a conversation conducted at Gerhard Richter's studio in 2007. The interview was devised as part of Corinna Belz's film, *Gerhard Richter's Window*, a documentary commissioned by the Staatliche Kunstsammlungen Dresden and the Gerhard Richter Archiv about the development of *Cologne Cathedral Window*. Belz shot several interviews for the film with those involved in the project, while Obrist was invited to interview Richter himself. A site-specific window, it replaced stained glass destroyed during the Second World War. Richter based the design on *4096 Colours*, his painting from 1974. Unveiled in August 2007, the window is comprised of 11,500 hand-blown squares of glass in seventy-two colours derived from the palette of the original medieval glazing of the destroyed window. The seemingly arbitrary distribution of colours was then generated using a specially developed computer program. This is the first time the interview has been published in written form.

OBRIST I recall that in earlier conversations you often hinted that you were worried that *Cologne Cathedral Window* might not work. Could you tell us how that story began? How did the initial contact come about?

RICHTER The head of conservation and restoration at the cathedral contacted me and said that they wanted a work to mark the auxiliary bishop's sixtieth birthday. They said that a window was available for a new design. Some at the cathedral wanted it to depict six modern saints, like Edith Stein[1] and others. I did experiment with that a little, making small sketches, until I realised that it really didn't work at all. After I had already rejected that idea, by chance I came across a reproduction of one of my earlier works, *4096 Colours* from 1974. I placed the window's tracery pattern over it, like a template, and it fitted so well that I was a little shocked. I thought, that's

4096 Colours [CR 359], 1974, lacquer on canvas, 254 × 254 cm

it, I will offer them that. It then took another two years until the cathedral chapter agreed to give it a try. That's how it happened.

It wasn't your first attempt to create a work for a church setting, though. There had been the earlier project for Renzo Piano's Padre Pio Pilgrimage Church in San Giovanni Rotondo, Puglia, in 1998; and later something on a very different scale in a very small church in Cologne. The thing with Renzo Piano didn't work out, did it?

No, it didn't, but it was clear it was going to be that way. Again, they were thinking of figurative art, of realistic painting, and I couldn't do that at all. My ability to produce something as a commission doesn't stretch that far. And then I just made something for myself, which I offered to them, and which, as was to be expected, they had to turn down. They had asked for something entirely different, after all. There was a bit of a fuss in the press, very briefly. 'Rejected by the Vatican', the papers said. That was nonsense: the Vatican hadn't rejected it at all.

And what had you proposed?

A series of rhombus-shaped Abstract Paintings. They fitted well into Piano's architecture, and it would have looked good. But I can understand why the church couldn't accept them. Anyway, the pictures are much better off now. They are hanging in the Museum of Fine Arts in Houston.

And then in 2001 there was the project in the Trinitatiskirche in Cologne.

Yes, that was also entirely by chance. I had found a photograph that somehow touched me. It was an US Air Force photo taken from above on 14 February 1945 that showed the Südbrücke [South Bridge] in Cologne, along with its surroundings, in ruins. It was so full of bomb craters. I thought it was a fascinating image. I had it restored so that it looked like a modern photograph, and then placed it behind glass. One of the ministers who was organising an exhibition in the church happened to see it, so I exhibited it there, and word got out. The following year, I made it again, in a large format, for the same church. I don't know what you should call it, that kind of public work. It's not decorative; it's something more like a commemorative image. But it doesn't have much to do with art in the sense that we're used to, art that hangs in a museum.

We talked about the idea of art in a chapel or church in our very first conversation. We discussed how it has something to do with permanence, which already interested you back then. Is the fact

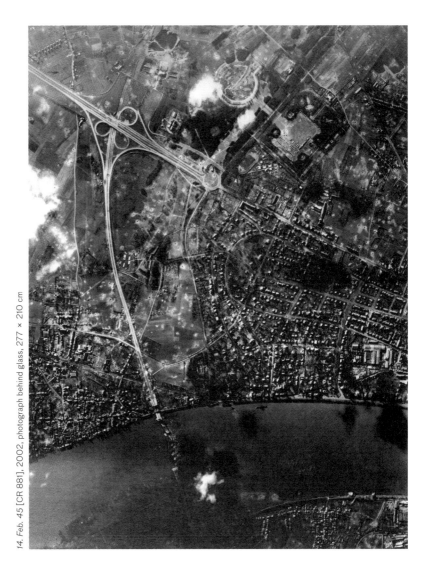

14. Feb. 45 [CR 881], 2002, photograph behind glass, 277 × 210 cm

that it is a permanent commission one of the important aspects of this request from the cathedral?

Yes, absolutely. It's like an ideal gift to receive, the opportunity to do something that lasts somewhat longer than yourself. Permanence. Eternity. And to create something for a public space is also fascinating in a certain sense, although people often turn up their noses at that sort of thing: for many artists, it's not done. But when it works, it can be very positive. Like the work I did in the Reichstag in Berlin in 1999, *Black,*

Red, Gold. It wasn't primarily about art, but was instead something that just belongs there.

Coming back to the work in Cologne Cathedral, you were describing how you came up with the idea. Could it be described as a chance encounter between the cathedral window and the postcard-sized reproduction of *4096 Colours*? An interesting point about that work is that it is not shown very often.

Yes, it is shown fairly infrequently. It was in a private collection for a long time, then it was sold and now it's in a private collection again. What was the question again?

Whether it was a chance encounter.

Absolutely. It had been almost thirty-five years since I had thought about that painting. But it isn't dead yet, it isn't over and done with, and I found that it fits in well with the window.

But let's look back on its history a little, how you started making that series. The first Colour Charts are from 1966 and continue until that work in 1974. Can you say something about the development of the series? Was there something in particular that triggered it?

Initially, it had something to do with the Pop art zeitgeist and the use of banal motifs. For some, there were newspaper images, publicity shots or advertising; in my case, it was the paint-colour charts that you found in the art-supplies stores. They looked so good I just had to paint them, and then I had a picture. They also had the advantage of not being as sacred as those, well, devotional pictures – to put it somewhat polemically – that people used to believe in and hold in such awe. You know: that's a Josef Albers, and it has a very particular tonal harmony, and that's an Antonio Calderara, and so on. I found the reverence people paid towards those works highly problematic. Grumbling about these things is particularly important as you get older. [*laughs*] So I developed what I was doing with the Colour Charts further, made it more systematic. At first, each colour was separated from the next by a slim bar of white, because I thought you couldn't let them collide; it would look dreadful. But that was just a step in the process, to show that it worked. It meant that I could put any colour alongside any other colour. And it almost always did work. That's so wonderfully anarchic, isn't it?

But at some point the bar vanished.

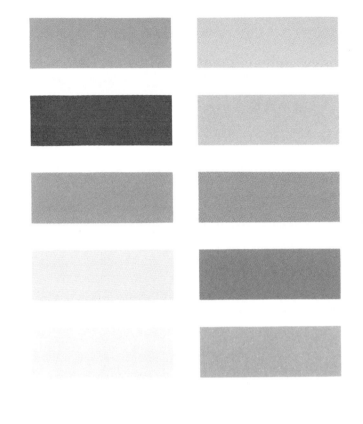

Ten Colours [CR 135-1], 1966, lacquer on canvas, 135 × 120 cm

Yes, in 1974 I started to paint the panes of colour so that they would touch one another, and I thought it looked very interesting. It is because they were all in a square format, which look so pixel-like, that it worked. If you just take the idea that you should act against something, out of an 'anti-' stance, then all you need to do is fling the paint on the floor. That's fine. But these works had to fit into a certain format, and a certain material: it had to be lacquer. Those were aesthetic qualities that you needed for it to work, to make an impact.

I grew up in Switzerland, and the abstract colour works of the Zurich Concrete artists Max Bill and Richard Paul Lohse were everywhere.

Lohse knew what he was doing.

71

But your Colour Charts certainly haven't got anything to do with that?

No. I met him once, at the 1972 Venice Biennale, where he had done the Swiss Pavilion [with Willy Weber]. One evening at some party, he said, 'You know, I've understood exactly what you did there.' He took it as being against him, which was fine. [*laughs*] Lohse was a nice guy.

Another thing that's interesting is that your series of Colour Charts, perhaps more than any of your other series, is reminiscent of those personified abstractions from the 1960s and 1970s, but it has nothing to do with that kind of abstraction. You could have imagined someone painting nothing but Colour Charts as their life work, but that isn't what it's about. It is just a series, after all.

Well, what I meant earlier about Albers and Calderara, and others too, was that I was troubled by the gestural dimension of their work; it's a form of personal expression. I wanted to pare that down as much as possible, so that the personal aspects were largely eliminated. We solved the question of which colours to place where by using a small tombola drum, with a number for every colour. We pulled out a number from the drum for position one, and that colour ended up there. Blinky Palermo would pull numbers out for a large section, and then me, and so on. Then along came a friend, someone who was interested in all this. I told him about what we were doing, and he said, 'You see, only Palermo could have got that one.' And then I knew we had to finish with that method. Believing is such a large part of it.

So there were rules of the game.

Oh yes, there were rules to follow. And everything was done very carefully, taped around neatly and painted precisely, with as little dust as possible.

Looking at the studio photos from the 1970s, you can see that it became an increasingly large-scale undertaking. What had begun with you modestly painting the Colour Charts turned into a huge operation almost like a factory with assistants.

There were five of us sometimes. Taping it off, painting the surfaces. I was teaching back then, and they were all students, except Peter Dibke, my studio assistant. It wasn't hard work. Perhaps the position was uncomfortable if you were kneeling. But otherwise, it was fun.

So what happened in the end? The colour works became larger and larger, but at some point in 1974 you just stopped. Had you tried out all the options; did it arrive at a logical endpoint? Or did you simply lose interest?

I simply lost interest. The last one was only 254 by 254 cm and had 4,096 colour squares. In fact, it has a thousand different colours, but each one was there four times. It created the most Impressionist of looks. With so many possibilities, the effect was really crazy. More than that didn't make sense any longer. When you've tried everything, then that's that. I lost interest.

But I have just started to do something like that again actually. We're trying to make a multiple of smaller paintings that would then be combined to make a large picture. Perhaps it will work. I've got two assistants, Norbert Arns and Hubert Becker, doing it right now. And I notice that we're really delighted because it's the kind of work where you are so much cancelled out. You don't have to think much. We'll have to take on a third and a fourth assistant too.

Each of the small paintings has twenty-five colours. These are arranged in fields, five by five. And you can do that one after another, in sequence, absolutely logically with yellow or orange, red and blue, and so on. And you can do it based on chance. Or you can arrange them according to mathematical progressions. I had someone calculate for me how many possibilities there are to arrange those twenty-five boxes, and there were, I don't know if I remember off the cuff, something like 5.5 trillion. But if you tried painting with just these few colours, first this one, then that one, you'd end up with maybe two hundred possibilities.

You mention these almost dizzying numerical series in the notes that you wrote about the *Cologne Cathedral Window* for the press conference. There, you describe that the starting point is four rows of colours – red, yellow, green and blue – and their intermediate nuances and varying brightness. How did you get from those four colours to 4,096?

Well, the first Colour Charts in 1966 were the ones from the art-supplies shop, and they were guided by taste. The range of paints that a particular shop presents and offers for sale is a matter of taste. And they were attractive works. Six lovely yellows, or the whole colour scale for garden furniture, or whatever... coloured gloss paint. And then, because there are three primary colours – red, yellow and blue – I always mixed them three by three by three, divided up into light and dark and based on the next hue. Then I read somewhere that Schopenhauer had said that there are actually four primary colours: green should be included because it's natural. That got me off the hook; in other words, I now had an excuse to

have four colours, instead of three, and so I added green. [*both laugh*]
And that led to the other paintings. It's really straightforward to do – four
times four times four times four, and so on. That's why you end up with
numbers such as 1,024 and 4,096 colours.

> Before we talk about *Cologne Cathedral Window*, in which you're
> revisiting those Colour Chart works, let us stick with that first
> phase for a moment. You have described their Impressionist or
> pointillist effect as being something like a coincidental figurative
> dimension. That is something that crops up again and again in
> the texts and conversations. And it is a point where you have a
> difference of opinion, if I can call it that, with Benjamin Buchloh.
> He talks about the reality of abstraction, and yet you say that
> there's always a certain narrative component too, which seems
> to introduce a kind of figuration into abstraction.

In some of the Abstract Paintings, I think that the eye is always looking for
something. A similarity with real things that we encounter, and that's the
basis for the effect that the paintings produce. That's why it's possible to
relate to them at all. And with the Colour Charts, the figurative dimension
is in principle always there, because with these X-trillion possibilities of
arranging the squares, at some point an image would appear, even every
conceivable image. And yet because there are so many possibilities, the
probability of me, or of us, creating an image by chance is virtually zero;
they always all look just the same. Each one is diffuse and non-figurative.
The dog never makes an appearance, and there's no swastika in them either.
That's the way it is. Although, at the same time, everything is in there.

> As a possibility.

Yes, as a possibility.

> I also find it interesting the way the white bars between the
> colours vanished at some point. I did a fairly lengthy interview
> with Gilbert & George last week. They always say that they
> could imagine their photo series as stained-glass windows in
> a church. Now, in those works, the bars between the panes
> always remain visible because of the framing. The framing is
> the bar. It occurs to me that your Colour Charts have more to
> do with Gilbert & George than someone like Lohse.

Yes, except in their work, that picture separated from the others by a bar is
figurative. And that's not the case here. That was my first reaction when the
auxiliary bishop and the Head of Cathedral Conservation and Restoration
said there is only one duo they could imagine doing this: Gilbert & George.

They make stained-glass windows after all. But actually, you can't do something like that in a cathedral. [*laughs*]

But that's an interesting paradox. In Gilbert & George's work, church windows are created in galleries through the presence of those separating bars, and the exact opposite happens with you: in your window, the individual bars, which are almost the defining feature of stained-glass windows, have vanished.

Yes, but this window has such a striking form. You can insert whatever you like beneath this tracery; it is always alright, it is always Catholic. And that is what made it so difficult. You could put this pullover under the tracery and it would be an attractive church window. Or an abstract image – they would be especially beautiful. Of course, I tried that too, with those lovely gestural ones, which are much more random than the Colour Chart. And that was the great drawback, and also why it didn't work. The Colour Chart gives you something more like a kind of shock, because it has such a simple and surprising effect.

In the case of *Cologne Cathedral Window*, the possibilities are reduced, because fewer shades of colour can be used than in the paintings. I think that the conditions of the material reduce them to seventy-two different colours, am I right? At the same time, the window will never be identical on any two occasions, as different light situations arise. So, on the one hand there is a reduction and on the other hand...

But also within the seventy-two colours, there are at least twenty times more. When the glass panes, which are all individually mouth-blown, are delivered in a particular red, yellow or blue, any slight differences in thickness create different tones. That already makes an entire colour scale, from the darkest tone to the lightest. Actually, there are lots more colour possibilities; the seventy-two just happened to be established. They could have produced more yellow tones than red tones, for example. But then the balance would have vanished right away. I wanted all the colours to appear on an equal footing.

So there's no hierarchy.

No hierarchy, yes. So it doesn't become a blue window, or a green one.

In all there are approximately 11,500 panes in the window, some of which are arranged randomly and some are placed in response to the architecture. And in fact, it's a window in two parts because there is a mirroring effect.

75

Ah yes, because half of the window is reflected. Only half is utilised and the other half is a reflection. Not a direct reflection though; it is not so heavy-handed. We tried everything possible there. It was dreadful. It looked like Mexican folk art. Little stick figures, going like this. [*demonstrates position of arms*]

> So there was a lot of experimenting, trying things out.

Yes, until we arrived at the size of the squares. The first ones we hung up were awful. Like kitchen tiles. It gave you a shock.

> In that respect, it is different from other projects where you revisit older paintings. Here it is something else. You are translating an earlier work into an entirely different frame, so to speak. It's not just about revisiting an image. It's about repetition and difference.

Yes, but the topic is exactly the same as before. It won't be done with until I... am gone.

> Something we didn't talk about at the beginning is the presence of Cologne Cathedral in your work. It's not the first time that the cathedral has played a role.

Well, it is the most beautiful building in this city, which is not exactly well-endowed with beauty. You can't help but notice it. It is a fantastic achievement that people built themselves something like that. To lift their spirits.

> In 1987, you painted *Cathedral Corner*, and again the following year. Were there any other moments when the cathedral made an appearance?

No, not so often. There was a failed painting of the cathedral's interior. I thought at one time I could do that as beautifully as Pieter Saenredam,[2] but it didn't work. [*laughs*]

> Saenredam, with those incredible church interiors. When did he become important to you and why?

It was a while ago. I can't really say much about it. He's simply good.

> And in our earlier conversations, you describe yourself repeatedly as an atheist. Has that changed in recent years?

Well, it's a bit glib, the term 'atheist'. It says so little. In the Church's sense, I am certainly an atheist, in that I don't believe in this God that the

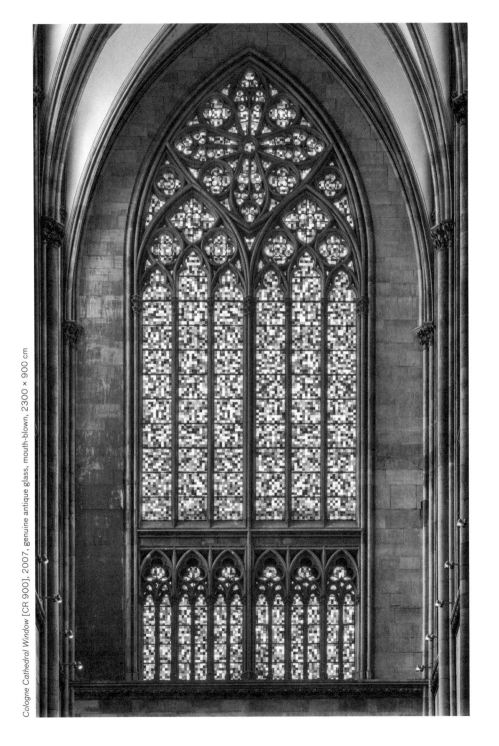

Cologne Cathedral Window [CR 900], 2007, genuine antique glass, mouth-blown, 2300 × 900 cm

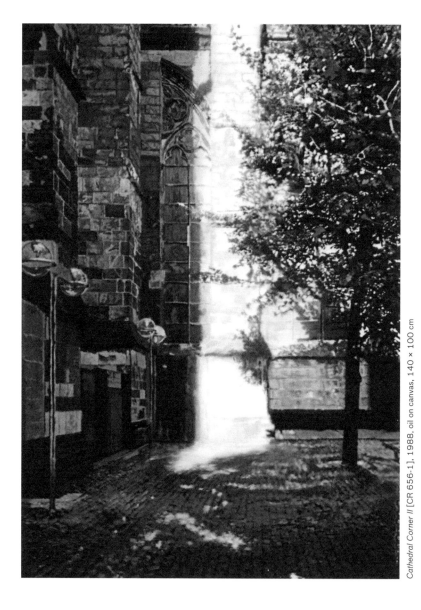

Cathedral Corner II [CR 656-1], 1988, oil on canvas, 140 × 100 cm

Church has defined. Very many people do believe in it, how exactly I don't know. I can't do it. But the idea that we believe, can believe, and can't do anything but believe, can't do anything but keep on believing, forever... If we no longer believe in God, then we simply believe in everything. That is so elementary and something that defines us so strongly, that we can't do anything but keep on, again and again, believing or questioning. Or both.

Yes. But this is such a sensitive issue, just as difficult as talking about love. I remember, back in the day when we'd be out drinking with Sigmar Polke or Konrad Fischer, and suddenly a subject like that would come up, there was immediately a sense of defensiveness and rage that someone had asked such an impertinent question, such an intimate question.

You mean the question of whether you're a believer?

Yes... so what do you believe in? [*laughs*]

But being able to believe is a simple urge, like eating and drinking. In other words, it is something very everyday.

Something that you really need to do, incessantly, and can't exist any other way. Because it is 'imagining' something. When I imagine that later I will do this or that, no animal can do that. Only we can do that. And that is what makes us alive. And pretending too, the fact that we pretend to ourselves about a great many things, so that we can bear them, are better able to bear this existence... That has been studied, the fact that people are constantly fooling themselves and pulling the wool over their own eyes.

I brought with me the new book by Richard Dawkins, *The God Delusion*, in which he writes about the irrationality of believing in God, and says that he sees how much damage the irrationality of faith does to society at present.

Damage?

Yes, damage, wars and violence and everything that religious belief is unleashing now.

Well, I think Christians cause the least damage, most definitely. And that a perverted faith that grows into fanaticism causes much worse damage. You see that every day.

Well, Dawkins says that rationality is vanishing.

I don't know if it ever – there have certainly been waves of this – if rationality was ever stronger. But just take a look at the last hundred years, and what we've done. One preposterous thing after another. It was a century of criminals.

The first time that this reference to Christian culture appeared directly in your work, it was on an entirely different scale from the large window in the cathedral, which is so monumental. It was in 1996 with a small work that was suddenly hanging in your studio. And I think it was somehow related to the ban on the crucifix in schools.

Exactly. Yes, it was more of a polemical work: there I was as a non-believer making a cross, and, to boot, out of something which was an incredibly precious material for me back then. It was in pure gold, heavy, and a real pleasure to touch. But there were only seven of them.

So it was meant polemically?

Yes, it was both polemical and I was also trying to make something beautiful and with human proportions, with my dimensions...

So you were saying there, 'This is my homeland, those are my roots, that is the tradition that I very much value, which is much more complex than all the critics think.'

Well... you know, this is where I come from, in other words, this is my culture. I think that we can call ourselves atheists, and thus show that we are still part of the tradition, of the Christian, Western tradition. But it is difficult to talk about such things, and I shouldn't do that. It's not my subject. You have to be a professional to... others can do it much better.

Nonetheless, I thought it's interesting to mention the small golden cross and to talk about it a little, because it does stake out a field that perhaps has something to do with this work.

But as so often, it isn't about anything. Perhaps people just thought, 'Oh well, he's getting old now.'

In your earlier statements where you talk about atheism, religion often appears with this idea of an ersatz religion. Would you describe art in those terms, as an ersatz religion?

Yes, definitely, I would. We look at it so devoutly. That is why art is most similar to religion and faith. Nothing works without faith. In that respect, I was of course very pleased that I got the commission and that I was able to develop my idea, which I like so much because there's almost no drama about it. I've seen so many series of ecclesiastical commissions, so many church windows, and they were always awful because they were putting on such an act. They behave as if they were producing holy glass art. And

Cross [Editions CR 92], 1997, steel, surface treated with hard wax oil, 19.5 x 19.5 x 1.5 cm. Edition of eighty. An earlier edition of seven, from 1996, was made in polished gold.

that's nothing but kitsch and hypocrisy. And for me it was... well, what is it? It's not a challenge, it's about setting up something a bit more honest.

But actually also an impossible situation, suddenly a chance to break through, break new ground.

Yes, that's just about it. Yes.

In your paintings, images from the past recur again and again; they were triggers. In this endeavour, in engaging with *Cologne Cathedral Window*, were there any church windows from the past involved?

No, none at all. I was not really very interested in them. In a certain sense, they don't have much to do with art. They are, at most, related to architecture and so are a form of applied art. You have to remind yourself, also in the case of my window, that it is, after all, a kind of intelligent applied art. And there is always an entirely different quality to that: it's craftsmanship. I felt better when I realised that I had to accept that, and that it was easy for me to do so. I was no longer thinking, 'Now I'm making a great artwork.'

And are there any cross-references with your other work? The project has been present in the studio over the last two or three years, in the form of trial versions and so on, and at the same time you were making a great deal of other works: new series of Abstract Paintings came into being in the studio, entire exhibitions. Are there points of contact or were these parallel universes?

I think it existed in parallel, because it has a different origin, forty years ago. And it is exactly the kind of thing that you can work on alongside everything else.

What are the other areas that you're working on at the moment?

I have done some Abstract Paintings, but at the moment, there's nothing at all. I'm waiting until something comes along.

There's a whole cycle of magnificent Abstract Paintings [p.88] that I saw last time.

I think they turned out pretty well.

They're magnificent.

I've only noticed that since they've been hanging here in this part of the studio.

They're being shown at this year's Venice Biennale?

Yes, but I don't know yet how things will be there. I can judge this [*points to postcards of Colour Chart works on the table*] pretty well, but not the abstract works. All I know is when something is finished. Somehow you do

realise. It's actually not that difficult. If nothing more occurs to you, you're done; also you know if something should not be discarded. The opposite can happen too, and that is fine; it's healthy when you throw one away.

And do you have any unrealised projects?

No, I hardly ever have any unrealised projects. Because if I do have an idea, then I start work on it. And if I don't have any ideas, then I don't mix with people, and no one knows.

For his annual question this year, John Brockman[3] asked all the most important contemporary academics, 'What are you optimistic about?', and I thought I would end this conversation by putting the same question to you: What kind of reason is there, or could there be, to be optimistic in 2007?

We can't help it. That would be my reason.

What's your view of the present moment?

I'm perplexed, as always.

1 Edith Stein (1891–1942) was a German Jewish philosopher who converted to Roman Catholicism and became a Carmelite nun.

2 Pieter Saenredam (1597–1665) was a Dutch artist, known for his paintings of church interiors.

3 www.edge.org/annual-question what-are-you-optimistic-about

'Like Bright Dust and Fog' was a conversation that took place in January 2007 at Gerhard Richter's studio and was first published in the May/June issue of *L'Uomo Vogue* in 2007.[1] The version printed here is the same as that later published in the book *Richter Text*.[2] In the interview Obrist and Richter dissect the *Cage* paintings and their unveiling at the upcoming Venice Biennale that year.

OBRIST I wanted to ask you what it means for you to partici-pate in the Venice Biennale under Robert Storr[3] this year?

RICHTER I take particular pleasure in the fact that Robert is doing this international exhibition. He's a professional in the best sense. And the Biennale is indeed a wonderful and important event – in all likelihood it's the best there is, despite the moaning that goes on. So I'm really glad I can be there and can show my paintings there.

Can we talk about the new paintings? This is the first time this unbelievable new cycle has been shown.

It's a series of six large paintings, and they have a special significance for me insofar as I still don't fully understand them. They were planned completely differently: that is, I wanted to paint them from photos that I had prepared two years ago; photos of various atomic structures compa-rable to the *Silicate* series [p.89] or the *Strontium* picture from 2004. These six photos promised beautiful, serious, somewhat disturbing paint-ings. And then when I had begun with the first painting, in late August, I suddenly lost the desire to work on it and proceeded to destroy what I had already painted, to paint it over without being conscious of what I wanted and where I wanted to go, and I just kept on painting like this somehow. This peculiar state of hopelessness, perplexity and high spirits kept on long enough for me to finish all six paintings. Of course, from time to time during the work I have fantasies about how the paintings could finally look. For example, at one point I thought the paintings would have to be completely white, with very little adumbration – like large drawings in oil on canvas.

Something like the large white paintings that were exhibited in Japan?

Yes, something like that. These concepts always get me very excited, but mostly they will have disappeared the next day, or a week later. And then I would start up again, nonsensically. In this way, they definitely are my freest paintings. And I never ever thought it possible they would be finished: I had no concept of final results. But then they were finished after three months, which means there was nothing more I could do with them. I was almost upset about it.

Because of a sudden emptiness afterwards?

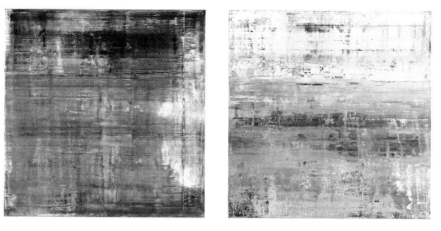

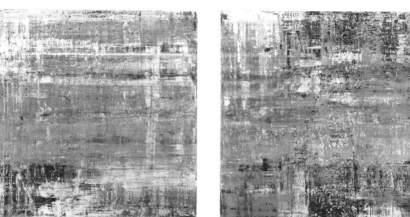

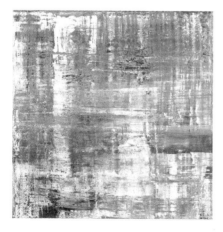

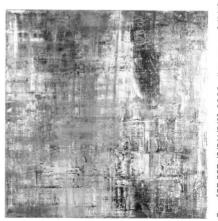

Cage [CR 897-1/2/3/4/5/6], 2006, oil on canvas, [1/3/4]: 290 x 290 cm, [2/5/6]: 300 x 300 cm

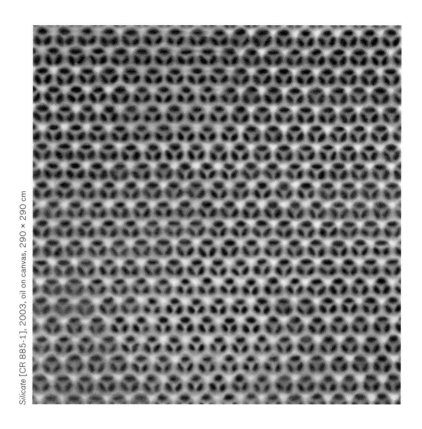

Silicate [CR 885-1], 2003, oil on canvas, 290 × 290 cm

Yes, that too. That's often the case when something is finished, and one feels superfluous and useless. But in this case that finished state of the paintings came quite unexpectedly, in fact almost disappointingly. I think I had felt I would be able to – or would have to – paint them forever. In any case, they were done, and the next problem was that I did not know what the paintings showed, and how I could title them. And it was you who helped me with a question. You asked me what music I'd been listening to during that period of work, and I answered: 'Cage!'

And with that you'd found your title.

In hindsight, I have to say rightly so. Because just then I had discovered – or rediscovered – the *Complete Piano Music* by John Cage, and I had been listening to it almost exclusively for a while. I still enjoy it today. Around twelve CDs, all of them with Steffen Schleiermacher. Wonderful. Of course, such a title is only indirectly linked with the paintings – it doesn't actually describe anything; it simply guides one's perspective in a certain direction,

89

towards certain connections and similarities. But also it signifies more than just a name. In any case, the title is meant to honour and express admiration for the music.

> Cage has had a long-lasting impression on you. You also once said that his *Lecture on Nothing* impressed you: 'I have nothing to say and I am saying it.'

Yes, that's true. Oddly enough, another connection just occurred to me, a visual similarity. Yesterday, once again, I saw this beautiful [Francesco] Guardi postcard, *The Gondola on the Lagoon*,[4] a wonderful little picture I'd once seen in Milan. I enjoy these kind of connections.

> And that brings us back to Venice...

Into the grey lagoon of John Cage.

> Wonderful! Perhaps we can speak a bit more about Cage and coincidence. You have spoken often about the concept of coincidence in Cage's and your own work, and it seems to be the case that coincidence plays a role again in these unplanned paintings...

Yes, a definitive role, even in the Abstract Paintings. Despite all my technical experience, I cannot always exactly foresee what will happen when I apply or remove large amounts of paint with the scraper. Surprises always emerge, disappointing or pleasant ones, which in any case represent changes to the painting – changes that I have to process first in my mind before I can continue. One can see, or rather hear, a great example in Cage's work of how extensively, cleverly and sensitively he treats this coincidence in order to make music out of it.

> You also spoke of Cage's discipline. You were interested in the notion that coincidence is only possible with a great deal of discipline. The same applies to these paintings.

Yes, otherwise they would just be smears of paint. Even with the Colour Charts, and now with *Cologne Cathedral Window*, these coincidences are only useful because they've been worked out – that means either eliminated or allowed or emphasised; in short, brought into a particular form that is skilful and artistic.

> When I saw your *Cage* paintings for the first time, in your studio, you were not yet certain if the cycle would have five or six paintings. It was as if the five paintings belonged

together, but the sixth was a part of the series, yet also not... can you say something about this? I believe all six are being shown in Venice.

Yes, the question of five or six was solved in time, because the first painting quite obviously belongs to the series, even if its appearance is somewhat different, somewhat softer than the following five. It now has the sense of being an introduction.

These new paintings are...

... more spontaneous, freer, not planned.

I would like to ask again – because something quite new is happening with the paintings that wasn't there before – can we possibly encapsulate what it is?

That's difficult for me to say. In the first place, I'm glad that I'm gradually able to recognise what the paintings show, that something is being conveyed, that they actually depict something, something quasi-real. But it will take some time yet before I can describe what it is.

You once said that in your Abstract Paintings there is a search for a likeness, which is always there...

Yes, it's always there. I think all abstract paintings function that way. We aren't capable of viewing paintings without searching for their inherent similarity with what we've experienced and what we know. To see what they offer us, whether they threaten us or whether they're nice to us, or whatever it might be...

A question about construction and deconstruction – because it's very interesting that this cycle began, like many of your Abstract Paintings, with an image that was then destroyed. And there are these several phases of image... where one can see all the painted-over images that no longer exist. It's actually a rather destructive act, and you agreed as we looked at them that this destructive act exists, but that alongside it there is the desire to create a well-built, constructive painting.

Yes, it's quite exciting to work that way, with destroying and building up, and wrecking again and so on. That's effectively a prerequisite – otherwise nothing will result. Only in figurative paintings is it any different; there, the destruction and construction are not as obvious.

91

Do you think these are optimistic paintings?

I'm beginning to...

I thought the Grey Pictures in your New York exhibition were much darker by comparison.

The ones I exhibited in 2001 with Marian Goodman?[5] They were actually a light grey, like bright dust and fog, but rather melancholic.

Somehow the *Cage* paintings bring a more optimistic quality... something of the principle of hope.

That may lie in a certain aggression and unpredictability that they possess, which makes them more optimistic than the *Grey* New York pictures.

Abstract Painting [CR 860-6], 1999, oil on canvas, 51 × 46 cm

And what is coming next? The paintings are finished, and it's always interesting to look towards the future.

I have no idea! Whether something new will come is a matter of my age and of fortune. I hope it will, and I'm ready for it.

We haven't yet spoken about the light in these paintings, about cold light, warm light, southern light, northern light... How would you describe the light in these paintings?

Abstract Painting [CR 860-3], 1999, oil on canvas, 102 × 82 cm

Abstract Painting [CR 860-7], 1999, oil on alu dibond, 100 × 90 cm

[*laughs*] Now that I've referred to the Guardi, with its gentle southern light from the lagoon, I think I have to describe it as northern light.

Perhaps that's the paradox of the light in Engadin [in Switzerland], where the south and the north – like Finland and Italy – collide.

Wonderful! Yes, Nietzsche described that so well. That's exactly what it is: the light of Sils-Maria.

Final question: there is this wonderful little text by Rainer Maria Rilke called *Letters to a Young Poet*, and I'd like to ask you what is your advice to young painters?

[*laughs*] Don't be easily led astray, and don't give up believing in art. That's all.

1 'Gerhard Richter' in *L'Uomo Vogue*, May/June 2007, pp.206–13.

2 Dietmar Elger and Hans Ulrich Obrist (eds), *Gerhard Richter Text: Writings, Interviews and Letters 1961–2007*, (London: Thames & Hudson, 2009), pp.528–33.

3 Robert Storr is an American critic and curator. Storr curated the retrospective *Gerhard Richter: 40 Years of Painting* at the Museum of Modern Art, New York in 2002.

4 Francesco Guardi (1712–1793), *The Gondola on the Lagoon*, c. 1765, oil on canvas, 25 x 38 cm.

5 Richter is referring to the Abstract Paintings [CR 867-1, 867-2, 867-3], 2000, oil on canvas, each: 250 x 175 cm. The exhibition took place at the Marian Goodman Gallery, New York, from 14 September to 27 October 2001.

The Impossibility of
Absolute Painting
1993

A Still Picture
1995

The Shape of
the House
2005

Nothing Works
Without Faith
2007

Like Bright Dust
and Fog
2007

A Distorted Form
of Legibility
2011

Grey in Several
Layers
2014

'A Distorted Form of Legibility' takes Richter's artist's books as its focus. The interview was conducted on 2 October 2011 – the Sunday before the opening of his Tate retrospective, *Panorama* – at The Savoy in London. It was first conceived for publication in *Gerhard Richter Books: Writings of the Gerhard Richter Archive Dresden*.[1] A selected list of Richter's artist's books can be found in Further Reading [pp.168–70].

On the subject of your artist's books, it strikes me that they got off to quite a slow start. Up until the 1980s, you produced relatively few, but after that things started to pick up. Little by little, they became increasingly important to you. It's also striking that they are very varied: some came about in connection with exhibitions, and some are completely autonomous. However, your artist's books are still a relatively little-known side of your work, so we've decided to talk about all of them, in chronological order. Your first true artist's book came out in March 1966. It was a joint publication, with Sigmar Polke, for the exhibition at Galerie h in Hanover. Could you tell me what the catalyst for that book was?

RICHTER That was the first important exhibition presented by someone we didn't already know. August Haseke – he was a teacher who had a gallery. We didn't want to just show pictures, so we also created a catalogue with that strange text.

Whose idea was the book, Polke's or yours?

We must have come up with it together, while we were preparing the exhibition. We had both read the *Perry Rhodan* weeklies [a German pulp science-fiction series]. In those days, we couldn't wait to get our hands on anything that other people dismissed as vulgar, that didn't count as literature. And Polke was the perfect person to work with for that. He was probably even more extreme in that respect than me.

And who did the text collages?

It's possible that I contributed more of the texts, but we selected and montaged everything together. The original collages for the catalogue still exist; you can see there who was responsible for which texts and our different attitudes coming across in them.

Besides the texts, that book also has a number of photographs taken by the two of you. Running through the city, at the cemetery...

... in our flats – we both lived in social housing. And of course, we didn't fill the bath with water for the shot in the tub!

What about the photograph where you've only got an animal skin wrapped around you?

Nothing special – just fooling around!

The catalogue didn't actually have much bearing on the exhibition.

That's true, it was just an additional extra. I'm sure I've still got some letter with precise lists of everything that was shown there. Nothing was sold, of course, that was normal. Actually, it's crazy that things like that weren't sold!

Uncle Rudi from 1965 [p.17] was in that exhibition.

Yes, and I gave him away later on.

To the Lidice Collection. But a publication like that surely hindered any sales.

Possibly, but in a way the aim was to make our pictures better understood, not to make them more sellable.

There's a long tradition of artists working with books. Did any of those influence what you two were doing?

I don't know. It was such an open time. Today things are even more open, but back then things were already so incredibly free that we always felt we could do whatever we liked.

Was it a feeling of complete openness?

Yes.

Could you shed any more light on the text collage you made together?

All the texts were pasted on. I think we sometimes even stuck together the photocopied, original texts, and that was then printed as it was.

Did you have any help, or was it pure do-it-yourself?

It was entirely DIY. We used to meet up and just have an incredibly good time sticking things together and laughing ourselves silly. And we also took delight in being provocative. Everyone else was making deadly serious catalogues, and we poked fun at everything. The actual catalogue (like some others later on) had no back cover, just two front covers: one for Polke and one for me, so each of us was named first.

That was a problem?

Among other things! In alphabetical order, I come second, but I had done the lion's share of the work, so that's probably why I came up with that idea. But the real reason for doing it was to make the catalogue look all the more unusual.

And there are some pictures of some really very strange-looking Happenings and Actions by you and Polke. Do you remember when you and he first met?

It may have been Konrad Fischer's doing. He was in Karl-Otto Götz's class [at the Kunstakademie Dusseldorf] and somehow he convinced Polke to change from [Gerhard] Hoehme's class to Götz's – the same way that he got me to leave [Ferdinand] Macketanz for Götz.[2]

Nam June Paik also mentioned Götz in an interview I conducted with him a long time ago. He said Götz had been an important influence on him because it seems he also did radar experiments. If you look at Götz's paintings, they can appear rather mannered – Informel and Tachist. But it seems he had another side that made him an interesting teacher.

He was also into cybernetics and painted pictures based on grids. But I didn't really know that side of him. He didn't exhibit those things and I barely saw any of them.

He didn't pass on anything about them to his students?

He didn't pass anything on at all – and that's exactly what was so appealing about him. He always used to come into the room by saying, 'Don't let me interrupt!'

So did you actually also organise your studies yourselves, like you organised that publication?

Yes. Götz didn't like seminars or crits with big crowds of people. So I used to load up all my things on a cart and take them to his studio and set them up there. And then he'd talk to me about them. Usually he'd say something like, 'That's an interesting direction. Do more like that!' [*laughs*] Or he'd tell me about the Surrealists, how things were back then. And, of course, that was also how he did in fact pass things on.

Looking back at your earliest artist's books, it's probably worth mentioning that in those days there used to be far fewer books on contemporary art. I was at Walther König's bookshop earlier today, and the number of books that students are confronted with these

101

Much fewer! I can't even recall any. Konrad Fischer, who was very well informed, used to get *Artforum* and *Art in America*. But they were just thin things. And they mainly just contained information – there was much less advertising than today.

So, what about early Warhol catalogues, you didn't have any of those?

Barely any at all. We used to discuss pictures of works in magazines. There was a small illustration of a [Roy] Lichtenstein painting, and I said, 'But that's no good either – just copying a comic.' [*laughs*]

And there was just one illustration?

Well, a very small number of illustrations.

That was 1966. So now we come to 1969 and the catalogue for the show at the Zentrum für aktuelle Kunst in Aachen. At first sight, it looks like a normal exhibition catalogue, but it's an artist's book. How did that happen?

I wanted the catalogue to be a catalogue raisonné of sorts. It was my first catalogue raisonné, and it shows the way I was thinking at the time, because that's when I first started to number paintings. Each painting was given a number, in chronological order, and any paintings without a number were not validated. That was the idea.

So, on the one hand, there are the free artist's books that followed the *Perry Rhodan* collages that you made with Sigmar Polke; and, on the other, there are the hybrid, mixed forms like the exhibition catalogues where you so radically changed the rules that they turned into artist's books. And those books started here. This was the beginning of your catalogue raisonné, wasn't it?

Yes, a bureaucratic foible of mine – but it was also more than that. I wanted to have an overview, in order to grasp what I was actually doing, to see if it was possible to discover some meaning in all those very different paintings that I didn't even understand myself. Other artists would pursue a particular theme that could be backed up by some theory; I could understand that. So I set about taking stock, above all by means of very small images of my works. That was a great help and a good way of learning how to distinguish good from bad, so that I could throw away the pictures that were somehow wrong.

So, in this case, compiling a catalogue or making an artist's book is about...

... ordering and evaluating. And that's easier to do using scaled-down pictures.

And that started in 1969 in the Aachen catalogue?[3]

Yes, that was the first time one was published. Although I'd started much earlier. In Dresden, I was already taking photographs of everything and making lists, so that I'd know what I was doing.

Which means that the show in Aachen was your first retrospective?

Yes. Klaus Honnef curated that show; he was very enthusiastic by nature and very open to ideas of that kind.

At the end of that catalogue, there's an interesting comment where Honnef cites Lawrence Alloway – one of the fathers of Pop art – who called you 'Europe's greatest painter today'.

Surely not!

Yes, absolutely. I didn't know he'd said that either. Did you know Lawrence Alloway?

No, only by name. We were so different from the Americans. Our work wasn't proper Pop art.

The interesting thing is that Lawrence Alloway was a product of British Pop art.

Which was a bit more varied.

Were you and your friends in contact with British Pop art?

Naturally – although I didn't really like it.

For artistic reasons?

Yes, it was too whimsical for me. I just thought, the cartoonist Saul Steinberg draws better than that – I really liked his work. So in a way that also helped me to avoid trying to be too witty. That was his thing, and he was great at it.

Steinberg had that covered, so other artists didn't have to do that?

Yes, his subjects are not right for art. I learned that from him. They make wonderful books – but not paintings. And there was also Richard Lindner...

… a late German-American Surrealist...

… who was very Pop-ish. And Peter Blake...

… and also Ronald B. Kitaj, Allen Jones and Richard Hamilton.

Hamilton was the most interesting of British artists. One whose work I've never liked, although he's certainly the most impressive, is David Hockney.

You felt closest to Hamilton?

Yes.

Coming back to your first catalogue raisonné – the catalogue for Aachen – the cover is also your work. A landscape with mountains shrouded in clouds. Where was that motif from?

It was a photograph I took on Corsica. Actually, that was the first of my landscape paintings. It was also my first holiday abroad – I really enjoyed taking pictures there.

So that was before you went to Tenerife?

Yes, I took some lovely photographs of the landscape there, too. But it was already a bit of an anachronism – painting landscapes – a bit ridiculous and old-fashioned. Stefan Wewerka saw that painting at Zwirner's and sent me a message saying that I was a 'real live wire' and that the picture was fantastic!

The artist and designer Stefan Wewerka?

Yes, the one who made the wacky furniture. He loved it. But the people who really helped me were Gilbert & George. Because they were rather old-fashioned themselves.

Their books are also a bit old-fashioned. There's a connection there to your books.

There was something nostalgic about them, anti-modernist. I really liked that.

In the Aachen catalogue, the way you toy with the notion of a catalogue raisonné is very interesting. The later Dusseldorf catalogue

[from 1986][4] with the list of works is also in effect an artist's book, and the same goes for the Paris/Bonn catalogue [from 1993].[5] But we haven't included those catalogues here in our list of artist's books [p.168–9]. So in a sense there are really three variants: pure artist's books, then the hybrid exhibition catalogues, and lastly the catalogues raisonnés, published in connection with the shows in Aachen, Dusseldorf and Paris/Bonn. But we've only included the first of these and not the later catalogues.

No, because they're not autonomous as such.

And yet these catalogues cast an interesting light on your game with the catalogue raisonné, and with the notion of order and disorder in some of your books. So, just one more question about the Aachen catalogue: *Table*, 1962, is already listed here as number one. When did you decide to start your list of works with *Table*?

I'd already decided that long before. It was the first painting I did after a photograph – I'd destroyed a few earlier attempts. It was a picture in the magazine *Domus*. It was a fairly modern table, which you can tell by the chunky legs and, as far as I remember, the square top. I made a painting of it, and it looked so terribly banal that I just smeared the paint. And then I thought, 'Well, that's not so bad, I'll leave it like that.' It's a strange thing, which has often happened since then: you deliberately spoil something and it looks better.

I often find myself talking to artists who – at the age of thirty-five or forty – still have no real idea where their catalogue raisonné should start. Often, it's only much later that they can say for sure where their student efforts stop and their real work begins. That's what makes it very astonishing that you decided so early on where your student paintings ended and your catalogue raisonné began. You even numbered the works straight away.

It was a very conscious decision. A bit naive, as though to say, now I'm grown-up and this is my job. But the fact that I'd numbered them soon proved to be very useful for sorting and archiving slides and photographs and all sorts of other things. I've done it ever since then, and it's a great help when things need to be authenticated – there are no works without numbers, even if it's there in front of you.

It's so interesting – how much there already is in that very first painting.

Yes. [*laughs*]

Table [CR 1], 1962, oil on canvas, 90 × 113 cm

So your third artist's book was the catalogue with prints for the exhibition at Museum Folkwang in Essen in 1970.[6] When we first looked at that, I couldn't see why this counts as an artist's book – it seems to be just a list of prints.

I should explain. I only included that one because of the cover picture. I numbered and signed a few copies because I wanted to claim the print on the cover as one of my prints, as my own work – in other words, as Appropriation art, although that didn't exist yet as such.

The cover picture is a print of the actress Sarah Bernhardt. However, the source isn't named in the catalogue. Where did you find it?

No idea! It was easy back then. You could just help yourself to anything without asking, no permissions – you could never do that today.

Sarah Bernhardt had a coffin made and then had a picture taken of herself in the coffin, while she was still alive.

Yes, I think I vaguely remember that story. At any rate, I was in love with an actress at the time and used the picture of Sarah Bernhardt as a substitute for the real person. It was a homage to the living actress.

> And the works are numbered in chronological order again, like the Aachen catalogue.

I am constantly reminded – even when I'm working on a major retrospective – that there's no better order than chronological order.

> So will the retrospective in London[7] also be hung in strict chronological order?

Well, not that strict. Exhibitions of that kind always involve a degree of compromise. You have to take the actual space and all sorts of other things into account.

> And your first print was *Dog*, which you made in 1965.

I found the motif in an album of family photographs, but I can't remember whom the dog belonged to any more. I made the print during an Action at Bahnhof Rolandseck, when Johannes Wasmuth invited a number of artists to work on prints in public. I pulled this screenprint and smeared the ink while it was still wet. But this public performance soon seemed so silly to me that I stopped after making just eight prints.

> So they're very rare...

... and expensive.

> The public nature of the process perhaps didn't suit you, but it's very interesting that you decided to smear the image in that context.

That's why all the eight versions are a little different, one-offs, more or less.

> Your next print was *Family* in 1966. And the motif was from a family album belonging to Ema, your first wife.

Yes, she came from a comfortably-off, well-placed family, a model family, it seemed to me at first.

> The Essen catalogue was published in 1970, and the next artist's book is another exhibition catalogue, for a show at Kunstverein Dusseldorf.

Dog [Editions CR 1], 1965, screenprint on a manually applied ground on lightweight card, 64.9 × 49.9 cm

That was in summer 1971. The important thing here is the catalogue design, which was again based on my tendency to make lists. The catalogue also has a fold-out showing the layout of the exhibition. As you can see, the paintings were hung rather close together. Quite recently, I came across a photographic version of *Eight Student Nurses* [p.156], which were in that show, and in fact I hung it in the studio just this morning.

> It's interesting that your exhibition catalogues, like this one, are not immediately identifiable as artist's books, but look like

Family [Editions CR 2], 1966, screenprint on lightweight card, 41.6 × 44 cm

perfectly normal exhibition catalogues at first, although you've slightly shifted the goalposts.

Yes, because I was very keen on being involved in the design of these books. The thing about this one is the cover, which went completely against the grain in those days because it looked so antiquated and old-fashioned.

This antiquated look is very interesting. Because at the time when you started doing things like that – in the late 1960s and early 1970s – Gilbert & George (with whom you were friends and whom you also painted) were doing something similar. In 1971, they published their book *Side by Side*; *Dark Shadow* followed in 1974; and they were also producing small pamphlets and postcards with seals and stamps. There's a connection of some kind there.

That's why I was so fond of them. I was very glad they were around.

There's a nice upbeat to the sequence of pictures in this catalogue: it starts with *Philipp Wilhelm* (number twenty-seven in your catalogue raisonné), which is followed by *Secretary* (which is number fourteen). So it's not a chronological order; there's a different principle here.

Yes, it's not chronological – probably because of the upbeat!

> So the upbeat was important. An old-fashioned cover and then this picture that could be from centuries ago. What inspired that painting?

A black-and-white reproduction of a painting in some very ordinary newspaper. I couldn't really say any more.

> It wasn't by an Old Master?

No, it wasn't a Titian or anything, which I would have seen myself in the original.

> Then, after the Dusseldorf catalogue, there's a very long gap. There are exhibition catalogues of course, but none where you were directly involved in the design, and no artist's books for a long time. The next one you worked on was *128 Details from a Picture (Halifax 1978)*, which was published in 1980. That was when you were teaching at Nova Scotia College of Art and Design in Halifax, wasn't it, one of the most experimental and most important art schools at the time?

Yes, I was a visiting professor for one semester. Benjamin Buchloh had persuaded me. Kasper König had asked Benjamin to go there, and when König left, Benjamin invited me. And he stayed there himself, which was good. But I couldn't paint there. I only had a small studio. However, then I did this exhibition and I photographed one painting in every possible way. I took it off the stretcher and laid the canvas over a chair so that there were folds in it...

> ... like landscapes.

Yes, like landscapes. That's how that happened.

> So it was different from the book *Abstract Painting 825-II: 69 Details* – which you published in 1996 – when you photographed the painting from the front, like real topography.

Yes. The details themselves weren't so interesting, it was the fact that I could see them as a landscape, like gazing at an alien planet that you were arriving at or flying over.

> The fact that it's in black and white and that there are micro- and macroscopic perspectives perhaps also creates something

of a connection to the photograph that Man Ray took in 1920
of Duchamp's *Large Glass* covered in a thick layer of dust. Man
Ray's photograph looks almost like a land-survey image taken
from the air. Was that in your mind at the time?

Only subconsciously, if at all.

Of course, you were also dealing with the practical constraint
of not having enough space to work in. That constraint was very
much a contributing factor. Did you also do the painting there?

No, I'd done all the paintings in Dusseldorf. Probably I hadn't dared to
show them in Germany. It was very much a new departure for me after the
paintings from photographs and other works that I was already starting to
become known for. But these Abstract Paintings seemed so different to
me – nonsensical, capricious. I found that very suspect.

And the paintings you had taken with you were all small
abstract compositions?

Yes, small Abstract Paintings. And I called the exhibition *Pictures*. It's a
cheap word – 'picture' – but it fitted what I was trying to do. I was then
very taken aback when it turned out that these things, which seemed so
strange to me, were taken just as seriously as all the other work I'd done
up to that point.

So it was like a test. You didn't want to exhibit those pictures in
any major art centre, like Cologne or New York, but somewhere
far away, on the periphery?

Yes, that's right.

And how did you come up with the idea of photographing details?

Perhaps I was a bit puzzled by my own painting – I'm not too sure any more
why I suddenly felt like photographing all those details. And in a way the
sixty-six Halifax drawings that I did in the evenings were just as puzzling.
Little sketches of nothing, like wandering about somewhere, aimlessly.
Gerhard Storck soon bought them for the Kunstmuseen Krefeld.

At the same time, there was also a very strong sense of order.
The 128 photographs of *Halifax* [the former title of *Abstract
Painting*, 1978] were organised in two ways: as a sequential
arrangement in the book, and as a photographic grid for the
presentation in Krefeld. On the one hand, there was an arbitrary

sequence, on the other, there was an almost conceptual, rigid grid. It's like an oxymoron – two things that don't belong together...

... but that also can't do without each other. That's the only way to deal with chaos. It's exactly the same with the Colour Charts. Everything in them is governed by chance – the sequence, the placement and so on; the idea is to come up with an order that works and that also properly reflects that element once. Without giving form to these things, you might as well just drop everything; then you'd have real chaos, nonsense, nothing.

It's interesting that later on you returned to the order you had devised for the first *Halifax* book, although in 1998 you used a different order for the second *Halifax* book, *128 Details from a Picture (Halifax 1978)*. Did you have an idea for a different book, or was that the book you had intended to make all along?

Abstract Painting [CR 432-5], 1978, oil on canvas, 52 × 78 cm

I'm asking, because in the new edition the photographs are not in groups of four on double-page spreads, but each has a whole page to itself.

Looking at it in a positive light, it's an attempt to let the individual shots come into their own better, letting you see them one by one. The original idea was not just to explore a planet as a system, but also to show how beautiful it is. As to whether that's what I've managed to do, I couldn't say. There are some images that are very interesting. But a book like that also

partly owes its existence to Walther König coming up to me and saying, 'Let's do something with that!'

The design with groups of four images in the first *Halifax* book has since become an important factor in a lot of your subsequent books, for instance *Sils*. But you first came up with that idea for *Halifax*, didn't you?

Actually, I imagine that design's been around for thousands of years. [*laughs*]

Only that was the first time you used it in your books?

Yes, as a strict system.

At the end of the book there's a publisher's note to the effect that, 'He [Richter] agreed.'[8] So the initial impulse didn't come from you?

That must be right.

And you agreed. So it's a 'quasi-artist's book', whereas the first *Halifax* book is an autonomous artist's book conceived by you. The next thing in our chronology is your adventure in Rome. In the early 1980s, the Pieronis loomed large in your orbit. They invited you to present your work at the Galleria Pieroni several times, and these exhibitions also led to two artist's books. One[9] is perhaps not really an artist's book, but it is listed in your catalogue raisonné of editions because you painted the cover picture. How did that come about?

That one just has a text, by Bruno Corà, and no illustrations. It's so wonderfully pure, don't you think?

It is wonderful!

Not a single picture, just the plain grey, painted cover.

It couldn't be purer. You did a number of books with Bruno Corà.

Yes, I really liked him, like all of the Pieroni clique – Jannis Kounellis, Mario Merz, Gino De Dominicis and all the other artists. Such wonderfully idealistic people.

But that book was really only the overture; the real artist's book was *Eis* from 1981. That's definitely one of the linchpins among

Eis [Editions CR 58], 1981, 20 × 12 cm. Edition of ninety, each with an individual cover completely painted in enamel.

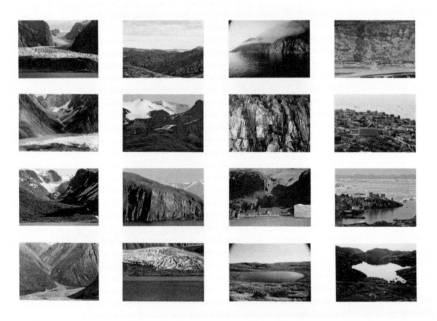

Greenland [Atlas Sheet 341], 1972, photographs on card, 51.7 × 73.5 cm

Yes, to Greenland. That was a good ten years before *Eis*.

You once mentioned to me that you had wanted to go there with
Hanne Darboven.[10]

Yes, that's right. We wanted to go to Greenland together. But for some
reason that never came to anything. And when I came back from Greenland,
I had so many beautiful photographs, but almost none that I could paint;
there were just too many, all of them beautiful, from that wonderful trip. I
had them lying on the table for a long time. Then I used some for a section
in *Atlas*. That was good, but I still somehow wanted to find another form for
these pictures. And so, very gradually, I came up with this little book.

So this book was made from photographs that were lying around
for some years, like the *War Cut* book later on.

Yes. I leave them lying there until I can deal with them one way or another.
But a lot of photographs end up in the trash can, if no ideas are forthcoming.

But that idea was wonderful, because *Eis* has several very
special features. One is that the photographs were printed
in black and white. Why was that?

Perhaps because these small-scale, black-and-white images make the
country look all the more mysterious and unapproachable.

And then there's also the upside-down layout with pictures
on their heads, which you did again in *Sils*.

Yes, upside down and probably also within a system where no two spreads
are organised in the same way. You can present four or three or two or one
or no pictures on a page and by also turning pictures upside down (left,
right, above, below) you can ensure that no arrangement is ever repeated.
A bit superstitious – using magic numbers – but also a bit silly.

It's very carefully constructed.

That's a tendency of mine, in order to avoid the situation where *I* come up
with something that is *my* taste. I hate it when artists say, 'I put that together'.
It's often much better when you, the artist, don't do anything and something
emerges of its own accord.

That would be ideal. As it happens, at the moment I'm showing some small *Strip* paintings at Marian Goodman's gallery (among other things).[11] These are based on around 4,000 strip patterns, fourteen of which were determined by chance – that's to say, 'blind' – and printed out like that. The interesting thing is that they're all equally good (or bad); depending on your taste or your mood, you might prefer this one or that one. And it's largely the same for the big *Strip* paintings, where a lot of patterns are combined together. Some were chosen very deliberately, others were completely random. And it seems as though no one can tell the difference between the two kinds.

Not even you?

No, actually not – although I know how they were all made. So, it's a kind of not-only-but-also: allowing something to come about by chance but then choosing the parts that work and reconfiguring those.

It's very interesting that you should say that, because that method is also very apparent in your books.

Making a virtue from necessity. Probably that's what we're all doing, all the time.

You made all the rules for *Eis*. And it also has empty pages – that was the first time you did that. It's become a hallmark of your layouts. There are sections with full pages, overpaintings and then pauses, silence and so on.

That's what always fascinated me in John Cage's music, in music in general: the voids, the silences.

These intervals and voids are wonderful. I also wanted to ask, how did it happen that you decided to paint an original cover for every book?

It made an intriguing contrast to the purist, quiet contents of the little book – using coloured paint in an almost random manner to make those pseudo-paintings.

Like the architect Peter Smithson would say, 'as found'. It's as though colour is initially removed, because you don't trust colour photographs, or because they're too garish – and then colour finds its way in again through a side door.

Yes. And then thirty years later it reappeared in the photographs again, in the second *Eis* book in 2011.

Could you say a few words on that? We were at Hotel Waldhaus in the Engadine [a region in the Swiss Alps], looking at the first *Eis* book; that's when the idea for the second version emerged.

That's right. No doubt it didn't seem exciting enough to just print a replica of the first *Eis* book. And I felt like doing something new with the old photographs – reintroduce colour and make them as beautiful as possible and add a continuous text. Because, however much I like the dry, conceptual *Eis* book from 1981, something would have to have changed thirty years later.

We once talked about the fact that, with our growing awareness of climate change, *Eis* has taken on a new relevance – the ice is melting. People who've been there have told me it's terrifying.

Those are people who know what they're looking at: experts. If I went there today, I wouldn't be able to see any difference. The ice sheet covering Greenland is so incredibly thick that it's going to be a long time yet before you can see the changes. And, in any case, it was already very surprising – forty years ago – to see that summery, green shore, with millions of midges settling on your clothing like a fine layer of fur.

In the new *Eis* book, there are two things that figure in a lot of your books: first, you appropriate and use texts; secondly, the way the pictures are arranged, with voids and intervals…

… so that as far as possible every double-page spread is different. A group of four photographs only produces five possibilities: no photograph, one photograph, two, three or four photographs. But then as soon as left, right, above, below, and text or no text come into play, that's enough to ensure that no two pages will look the same.

In that respect, it's like *War Cut*: no repetition.

Yes, but that was also arranged in a strictly symmetrical order.

And what made you decide to include text? Because it's not only in the new version of *Eis* that text has a part to play, but also in *Wald*, in our book *OBRIST / O'BRIST*, and in *Sindbad*. And you also used found text in these ones again, 'as found'.

Of course, it's actually the norm that a book has a text, but I couldn't say exactly why I specifically wanted to have text in that book. Whatever the

case I was very happy when at last I found that description of Greenland in an old encyclopaedia. I just had to shorten it and edit it.

> We can perhaps return to the matter of texts later on in connection with your book *Wald*. As to books that are connected to *Eis*, *Sils* from 1992 immediately comes to mind, because that also has upside-down images and blank pages. That book was made for our first collaboration – our project for the Nietzsche-Haus in Sils Maria. I had often visited you in Sils Maria when we were both on holiday in the Engadine. In 1991, we spent a few days there in the Waldhaus with you and Isa Genzken. We talked about doing an exhibition there the following year, and that's how the project came about. And then we put on the exhibition at the Nietzsche-Haus. At the time I'd already started putting on a discreet exhibition in the monastery or in my kitchen, so this one was also intended to slip reasonably inconspicuously into the museum exhibition.

Yes, we managed that. Subsequently there were other exhibitions that took the space over in a rather brutal manner.

> Yes, sadly. Could you perhaps say something about the layout of *Sils*? When we were planning the book, we looked at a little book by Lawrence Weiner, whose books you liked a lot.

Yes, that was certainly worth looking at. But ours turned out rather differently, because of the way it developed as we were working on it.

> And again, as in the case of *Eis*, the layout you designed is very unusual. There are pauses, intervals, silences, with groups of four pages, asymmetrical, with double-page spreads, a blank page on the left, one on the right, with the upper half empty, the lower half empty, and so on. It's almost like a composition.

Yes, that's how it was intended. A structure that's different on every page. You might also say that it demonstrates such a lack of trust in the book's message that it was necessary to invent an artificial source of interest. [*laughs*]

> I don't think we should be so negative. It's also like a red thread that runs through all your books. It was there in *Eis*, and *Sils* also has upside-down images.

It's the same principle – you see, I've got no new ideas, the same thing every time! Like the mirror images.

Those double-page spreads with similar motifs are almost like Rorschach tests. One thing that struck me when we were working on *Sils* concerns the titles of your books. All the books that mean the most to you, that you really did yourself – be it *War Cut*, *Stammheim*, *Sils*, *Patterns*, *Sindbad* or *Eis* – have very concise titles.

Yes, and there's *Wald*, too. If I were a writer no doubt I'd have proper titles, as opposed to these ones, which are just short markers, to distinguish one book from another.

I remember when we were working on *Sils* and I kept coming up with titles like 'Nietzsche und der Circulus Vitiosus Pictus', and you pointed out that in ten years' time we'd 'all look a bit silly with a title like that. We need a short title.' Your way of coming up with a title is very economical. You just said, 'Where's the exhibition happening?' I said, 'Sils Maria,' and you said, 'Too long, Sils.'

Later on, it was the opposite way round. I asked you what I should call the large paintings, and you asked, 'What music have you been listening to lately?' And when I said 'Cage,' that settled the title.

It was your own method in action!

Yes – beautiful titles like *Le désir tragique*[12] can only be used by writers.

Except that's not an artist's book. It's a book by Birgit Pelzer, which you illustrated.

'Tragic desire' – a wonderful title.

And what inspired the Overpainted Photographs in *Sils*? You often went back to Sils Maria and took a lot of pictures on these trips, as you did others, too...

Yes, there were plenty of Overpainted Photographs, including pictures from Sils. But these had the distinct advantage of depicting the mountain world and were small enough for the Nietzsche-Haus.

When did you start overpainting photographs? Was there an epiphany? Do you remember what prompted the first Overpainted Photographs? Are they in *Atlas*?

Yes, the earliest Overpainted Photographs are in *Atlas*. When I was working on representational paintings based on photographs, I used to dab some

paint on the photograph to check the colour, to make sure it matched. When I was finished, the photograph was covered with little dots of paint and looked much more interesting than before. And then I started doing the same thing, but now on purpose.

So it was a chance discovery?

Initially, yes.

When we were working on *Sils*, I remember seeing several photographs with little spots of paint on them.

Except I made those artificially, for instance with red mini-sprays.

Our *Sils* book is in fact a bit like a guide for visitors to this landscape. It's got all the mountains around Sils Maria: Piz Boval, Piz Rosatsch...

... Piz Chapütschin – and so on. You could never come up with a better title than that.

And the spheres that were made for the exhibition, they were also named after mountains.

Yes! Those spheres went back to an old print by Polke and me, where we turned a mountainous massif into a sphere: a youthful yearning for omnipotence.

Below the image there is a caption in German to the effect that these are 'Five stages of a transformation undertaken by Polke and Richter. On April 26, 1968, the mountain was transformed into a sphere for the duration of two hours.'

[*laughs*] Yes, and then that sphere became a reality.

Soon after *Sils*, you made the little *Stammheim* book from 1995 – not with Overpainted Photographs, but with overpainted texts...

... which have a very similar meaning.

It's one of my favourite books, because it's so tactile. It also has something very fragile about it. And the special thing about this one is that that book was already a book: twenty-three pages from *Stammheim: Der Prozeß gegen die Rote Armee Fraktion* by Pieter Bakker Schut have been overpainted. It's a

found book, an *objet trouvé*, isn't it? Could you fill in something of the background to that project?

It was a subject that I was preoccupied with for a long time. The main outcome was *October 18, 1977*, that series of fifteen paintings.

And what made you choose the Pieter Bakker Schut book?

I had a copy at the time. It was very detailed and I wasn't getting very far with it. Nevertheless, when something like that is just lying there with its very serious contents, it can make you feel very uneasy – to such an extent, in my case, that I just wanted to get rid of it and started overpainting the pages.

Stammheim has a very good foreword by Anne Seymour.

Yes, I can even vaguely remember particularly liking the last sentence.[13]

The whole text is good. It's interesting that those overpaintings didn't become a series, and that that is the only time you have overpainted a book, isn't it? You've tended to do that more with newspapers, such as the *Frankfurter Allgemeine Zeitung*.

Actually, I only once overpainted the *Frankfurter Allgemeine*, for an advertisement, and then that came out as an edition. Later on, I destroyed other texts in a different way.

In a sense *Stammheim*, as an artist's book, anticipates what you did later on, using a computer to mix text – it's pre-digital.

Only that *Stammheim* is about obliterating, so that it becomes good to look at rather than remaining legible. In the case of those later works, they were still about legibility, albeit a distorted form of legibility.

Stammheim also has a very classical cover.

It's not unlike the cover of that great book *Extinction* by Thomas Bernhard, my favourite writer at the time. And my book was also a form of extinction, although sometimes overpaintings remind me of a fresh covering of snow that calms everything down so beautifully.

When did you discover Bernhard's writing?

In the 1970s, when I was teaching in Dusseldorf. A student mentioned a writer who would surely interest me. I asked, 'Who? What's his name?' And I was immediately hooked.

And ever since then you've read everything of his...

Yes.

So it's an indirect homage to Bernhard!

Yes, that's true.

But you never met him, did you?

No. I was maybe going to meet him at one point. A publisher approached me to ask if I would do something for him or with him. But I said, 'I don't think he'd want to. Ask him and see.' So he asked Bernhard, who apparently just shrugged his shoulder and said, 'Don't know. Don't care one way or the other.' So it's good that we never met. What would we have talked about?

You think there would have been nothing to talk about?

Definitely not.

After *Stammheim*, you soon started to make more and more artist's books. At some point, you and I agreed that we should always be working on a book. Whenever we weren't working on a book together, there was just something missing. So a whole number of books came about. In the same year as *Stammheim*, 1995, you also started work on *Abstract Painting 825-II: 69 Details*, which partly arose from our work on the book of writings and interviews with Gottfried Honnefelder and Insel Verlag.[14] You were always somehow fascinated by that series of Insel books upstairs in your house. That series was the trigger, wasn't it?

And the small painting that you particularly liked.

Yes, I've always liked that painting.

And it seemed to me to be so different from the others in its details, which was why I photographed it.

The method you used for *69 Details* was not the same as you used for the details of *Halifax*, which was very topographical. It was as though you were flying across *Halifax* – but the process in *69 Details* was systematic and frontal.

Yes, and the *War Cut* is a mixture of both approaches. The details were photographed from the front because they looked like autonomous forms, almost like surreal figures that you just had to photograph as they were.

There are a lot of drips and holes…

Yes, rather like *Souvenir* from 1994, the painting I cut up and used to make miniatures…

… the very small paintings that Anthony d'Offay showed – nano-paintings, so to speak. In *69 Details*, there's an afterword by me, but the only text by you is that mysterious dedication 'Für Elise'. Perhaps we could talk about that?

Beethoven wrote that beautiful piano piece *Für Elise*, and it just seemed right to me to add that reference, to convey a sense of the rather tender nature of the work and its affinity with music.

And it's also interesting that you can't fathom the system. You can look at it as often as you like, but you can never really work the system out. It's like Tristan Tzara once said: 'The absence of a system is also a system, and that is the most appealing system of all.' I cited that before the afterword. There's a connection there somewhere.

Yes, I'd say so, too.

Most of your artist's books are fairly clearly defined. In some ways, they call to mind Sol LeWitt's Conceptual books. But at the same time there's no systemic order in the way you select details. If the reader tries to seek out the coordinates underpinning a work, it's soon clear that it is relatively freely structured. There is a system of sorts, but a very open system – if anything, you could describe it as associative.

Although I'm generally not that aware of what I'm actually doing – you just do it.

And it was like that earlier when you were working on the *Halifax* book, and again later when you used *Abstract Painting*[15] in 1987 and *War Cut* in 2004?

Yes, but simpler. I had the painting myself, it was small, and the details were somehow photogenic. In Paris, it was much harder looking for details, up a ladder, under time pressure, and in poor lighting. I didn't even know exactly

what I was looking for. That's why there are a lot more photographs than I in fact needed.

And might you go on doing that, photographing details? A lot of your Abstract Paintings would certainly lend themselves to that.

If anything, I'd say that's been done now, done and dusted.

So, as we've mentioned, after *69 Details*, there was *War Cut*, one more book with details. I was at the Musée d'Art Moderne de la Ville de Paris in those days, which closed for a whole year. You and I discussed what a museum can do when it is closed. One thing we came up with was visiting works in the collection. So I suggested we should meet in Paris. And you revisited your *Abstract Painting* from 1987, which is in the collection there. Then we talked on the phone and you said it would work well for details. So we met at the museum for a photoshoot.

The real reason was that I couldn't understand at the time why the museum had bought that particular painting. I felt it was a bit bland, that there was nothing especially striking about it, nothing eye-catching, and that's why I wanted to have another, closer look at it. Now I know it better, of course, but there's still something impenetrable about it, something enigmatic – and the same goes for its details.

An enigma meets an enigma. It is very dense, it's multi-layered. But it's not your favourite painting.

It seems to be one of those that get better with time – which is always rather pleasing.

The great thing about retrospectives, like the one at Tate Modern, is that it's a chance to see a lot of works that one hasn't seen for a long time. Did you make the selection for the show?

As ever, it was a compromise – reached by the three museum directors, their three curators, and me. And then there are the setbacks, when it's not possible to include such and such a painting. In a way, retrospectives are always compromises that you have to make something from.

But it's also a new constellation every time.

Yes, yes. And time always casts things in a new light.

It almost seems that you could have an infinite number of retrospectives. There are so many different ways of making connections. You could calculate the permutations – like your *4900 Colours*![16]

In theory!

But, to come back to *War Cut*: unlike the Insel book, the images are neither strictly frontal nor systematic, which makes it more like *Halifax*, only it's in colour. Some parts are hazy and blurred, others are in sharp focus; in some parts there are tiny details, in others there are much larger details, and so on. It has a greater sense of freedom than the Insel book.

It is freer and has more narrative. And the text adds an additional charge to the images. If an image is dominated by red and there's talk of 'explosions', it's as though you can see them in the image, or in others you can see the parched earth, and so on. That's something I very much like: that you can always see something in a picture. It's the lifeblood of Abstract Paintings. We always want to see something!

During that project there were one or two moments when you somehow doubted what you were doing. You almost wanted to call it off. You felt there wasn't enough material and we couldn't do anything with it. The images and materials from Paris lay around for a while, and you were rather unsure as to whether they could come to anything...

... and then the war intervened!

Yes, Iraq was invaded on 20 March 2003. Not unlike Lautréamont's famous 'chance meeting on a dissecting table of a sewing machine and an umbrella' in his *Songs of Maldoror*, there was that almost surreal juxtaposition of the *Frankfurter Allgemeine Zeitung* and those photographs on that first day of hostilities...

... and the connection arose of its own accord.

All of a sudden, they were images of war.

Yes.

And that was the first time you used text collages. In *Stammheim*, a found page from a book served as a

125

It does, actually – the texts are taken from somewhere else, word for word.

Yes, but I didn't devise the contents, nor were the texts written for that book:
I just used them, appropriated them. And in that different context, without
headings, the texts look like literature.

Yes.

All the texts are about the beginning of the war, looking at it from different points
of view – economic, military, critical, protesting against the war, and so on.

Yes, and as far as I can remember, they were all published on the first two
days of the war.

It's pretty much the only paper that I always read.

When I first went to the Academy in Dusseldorf in 1961 it was available there,
free of charge. One day Konrad Fischer said to me, 'You should read that,
it's good!' And ever since then, I've been reading it. I've cancelled my sub-
scription twice, when the nonsense in the arts pages just became unbearable.
Last time, my wife renewed the subscription, so I'm still reading it.

Yes, for instance that beautiful picture of the first view of the inside of an
atom: *First View* from 2000. *Hood*, on the other hand, from 1996, came

about purely by chance. I always use old newspapers as scrap paper. I happened to wipe my brush across that picture and was rewarded with a lovely overpainting. But sadly that sort of thing is very much the exception.

And there's also an overpainting of a double-page spread, which was then reproduced in the *Frankfurter Allgemeine Zeitung*.

Yes, that was part of their advertising campaign [a picture of someone half-hidden behind the paper, reading it, with the caption, 'There's always a bright spark behind it']. I'd been asked to make something for it. There was a photograph of my paint-smeared hands holding the paper, which I then overpainted.

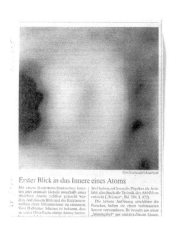

First View [Editions CR 112], 2000, offset print on paper, mounted on card, 18.2 × 15.1 cm

And then there was that chance encounter that led to *War Cut*. You also chose the material for the cover. When you're working on your books, you often select very specific materials. You wanted the cover to be red and for it to be hard yet still flexible – your ideas are always very precise.

Yes, the cover has to be in keeping with the contents and not just be somehow attractive.

The red is also very dramatic.

Yes, it's a bit like a primer, a handbook of military rules and regulations.

And the process always goes on even after the book is done. In the case of *War Cut*, first you took the photographs, then there was that unplanned juxtaposition with the newspaper, which led to a book. But that was not the end, because you then overpainted the covers for the limited-edition *War Cut II* from 2004 – with fantastic paintings, in fact. However, the next book we're going to talk about, *Snow-White* from 2006, is something of a dilemma. I love it, but you were never entirely convinced that it is an artist's book.

That's right, because I didn't design it. It was all done by Kiyoshi Wako. I didn't have a part in it, not even to give advice. That's why it turned out so well. [*laughs*]

Gerhard Richter Snow-White

Cover of *Snow-White*, published by Wako Works of Art, Tokyo, 2006

Could you say something about the paintings? They are all similar, basically white, but there are also fine lines on them.

They're offset prints of Abstract Paintings, which I overpainted with relatively thin white paint and then added drawn lines.

Snow White (2/100) [Editions CR 132], 2005, acrylic and graphite on offset print, 22.5 × 32 cm

The starting point was a painting?

Yes, two paintings that were actually supposed to form the basis of an edition, which is why I had one hundred or two hundred sheets of these. And since they were no good as they were, I overpainted them with white.

It is a fantastic book. At any rate, the next book in our chronological list is *Wald* of 2008, which is very much an artist's book. It also has a found text and took a long time to make. Could you describe how it came about?

It's a late work! [*laughs*] No really, the way I was fascinated by those thickets, constantly seeking out those places off the beaten path, the way they seemed so beautiful and comforting to me – I took photograph after photograph – that has to have something to do with aging and the anxieties of aging. Whatever the case, it was an immensely satisfying project. It could be that that's my favourite book.

129

You took a lot of pictures in the woods, and then it was a long time before the pictures found their text. It was not unlike *War Cut*.

Yes, it was another coincidence. Someone or other sent me a copy of a magazine called *Wald* or *Waldung*. It had stories about woods and forests, but you couldn't use them as they were, so I turned them around and made them unrecognisable. And then I worked it into a system of quarter-pages with the text always in a different position on the page.

In this rearrangement of the texts, chance plays a much greater part than in *War Cut*, where the texts could better be described as readymades, although they are a different kind of readymade from those in *Stammheim*, because the text for *War Cut* was reset. But *Wald* was the first time that you used a random number generator…

… which really made the text unrecognisable.

It's like overpainting pictures, it completely destroys the original material.

And yet something of the mood is retained, because the vocabulary is still the same and has to do with trees and forests. Sometimes I can even read it myself with some kind of appreciation.

I've also often reread those texts, because you can also read them as non-linear progressions. And then there are also the twelve, great Abstract Paintings from 2005, also called *Wald* [here *Forest*], which I saw at the Getty.

You also saw them before that in the studio in Cologne. It turned out well, that cycle.

It's major work. What was the catalyst for that one? Because it actually came about after the *Forest* photographs that eventually became the book.

Yes, and there's actually no direct connection between the photographs and the paintings. Although the book and the paintings have the same name in German, the paintings have nothing to do with any actual wood or forest.

In the Getty Museum catalogue, there's an interview on the subject of these paintings between you and Jeanne Anne Nugent.[17] It was also reprinted in our book of writings,

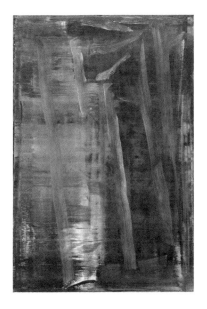
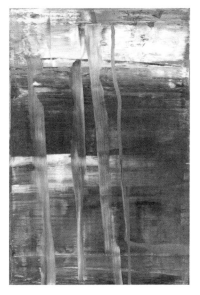

Forest [CR 892-3/2/6/11], 2005, oil on canvas, each: 197 × 132 cm

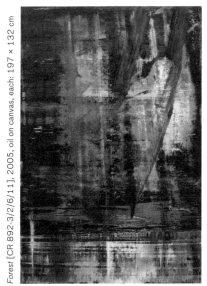

interviews and letters published in 2009. She makes the connection between your work and the paintings of Caspar David Friedrich and Romanticism in general. You then point out that uncertainty was the driving force in these paintings. Various things that we have talked about today also crop up

in that interview: the Alps, tradition, Friedrich. Looking at your *Forest* paintings, Nugent suggests that they have something to do with Friedrich. And you come up with a very interesting reply: you say that it's true there is an affinity with Friedrich, but that you can't exactly explain why. You agree that these twelve very dense, very scratchy Abstract Paintings were done in the spirit of Caspar David Friedrich, and you add that you prefer these to be seen as a link to Friedrich instead of the superficial connection that is constantly being made in the context of your painted landscapes.

Yes, that's right.

So there's more of an internal connection to Romanticism?

Yes, maybe it's just a tendency to melancholy, or something of the sort. I see more of an affinity in the twelve abstract *Forest* paintings, despite that uncertainty, as though one had lost one's way. They're like depictions of the feeling you have in a forest that you don't understand.

It's like the feeling your son Moritz described yesterday: you wander around in the forest for hours on end and lose all sense of orientation in those paintings. When he made that remark yesterday, I immediately thought of your *Forest* paintings.

He was very affected by that...

I was briefly in Vienna earlier this week, and I saw *Park Piece*, that large five-part painting you did in 1971. It could have been done yesterday – it's yet another, very different painting.

Yes, that was all about the joy of just playing with the paintbrush as you liked. The colours were mixed very carefully to exactly match photographs. But when I then set to work very freely and loosely, the painting automatically turned into a park piece! It was such a surprise.

And it couldn't have turned into a forest?

Yes, that's more or less it. [*laughs*]

What *Wald* has in common with the book we did together not long afterwards is that it has a text that was deconstructed by means of a random-number generator. In fact, that book was something of a chain reaction: I'd asked you to do a cover for the second volume of ...*dontstop*... in 2006, as you'd already

Cover of ...dontstopdontstopdontstopdontstop, published by Sternberg Press, Berlin, 2006

done for the first volume – and all of a sudden it turned into so much more. And that was the beginning of the next book: *OBRIST/O'BRIST* published in 2009.

And how did we come up with that text? Did I find it?

Exactly – it was the same process as *Wald* and *War Cut*, you found the text. Because the cover was for the book of text by me, you said I should send you all my texts...

... and then there was that moment of brutality. [*laughs*] That could have gone horribly wrong; I mean, you could have taken it as an insult. I thought it was great that you just accepted it.

133

Blatant iconoclasm! [*laughs*] You can read that book from both ends – it has two cover pages, and the text and the photographs are printed in two directions. I find it interesting that you did this cover as a relief overpainting, as a three-dimensional image. You had that idea when you were making that cover for the *...dontstop...* book with M/M in Paris, who designed it.

And I liked it so much that I did the same for our book [*OBRIST/O'BRIST*].

It's so tactile. Inside it, as before, there are intervals and pauses. In addition there are also very scratched, Abstract Paintings. How were they done? First the photographs were overpainted and then some paint was removed again, was that it?

They're not overpainted. They're photographs of surfaces of paintings by me, which I then treated by scratching them or tearing whole strips out of them.

The scratches remove colour and produce a drawing of sorts. So something has been removed. It's the opposite of an Overpainted Photograph, it's a de-Overpainted Photograph! They're great and very unusual – and they're unprecedented.

That's right, they were done specifically for that book.

Following that book of ours the next book was *Sindbad* from 2010, which had a very slow birth. It's almost a facsimile of the enamel paintings, so to speak. Could you say how those enamel paintings came about?

Well – when you have reached a certain age and are not so frightened of getting too close to kitsch, you can do something like that. [*laughs*] I'd always liked enamels. When I was working with Pieroni on the covers for the first *Eis* books, I also poured some enamels. All different covers, each one prettier than the last.

Each book is an original work of art.

I did something similar in 1998, for the twelve *Rhombus* paintings from 1998. And for another two editions – photographs of enamel paintings. But in the case of *Sindbad*, that was the first time I had done them for their own sake. In other words, these ephemeral enamel paintings were not photographed but directly captured on a sheet of a glass. It's a fun way of working, and in a sense an incredibly easy way of making pictures.

And the Sinbad *paintings were intended as a cycle from the outset, were they?*

Actually, without really meaning to I made over fifty pairs.

And all these double images then constituted a single work?

Yes, it just turned out like that when I saw the fifty pairs of images on the wall, looking exactly like double-page spreads in a book. A collector in America has them now. No doubt he was delighted later on when he also got a lovely book about *his* work.

I never saw you making those pictures. I only ever saw the results in your studio. How did you do them?

With great relish! [*laughs*] You pour different colours of enamel onto a sheet of glass. The enamels run, and you use some kind of an object to help them along, changing the direction, removing or adding paint as needed. And then the look of them changes of its own accord, because different colours merge in places. And as soon as it has reached the point where it seems interesting enough, you take another sheet of glass and lay it on the paint – and the exact picture that has just emerged is now fixed for ever. It's very magical and almost unfair, in a way.

You make a decision and in that same moment you freeze the image?

That's right. It's just like photography, in fact. A different form of photography.

The business of waiting is just as important as the act of painting – so that you are neither too early nor too late.

And then there's also the matter of choosing the right section, because the original sheet of glass, now covered in enamels, is larger than the picture glass.

And that's the painting finished.

Yes, because I can't change anything after that. It's take it or leave it. Dan Flavin once put it very nicely: 'Art is all about milliseconds' – suddenly something's there or it's not. That's how photographers work; that's how we react to things all the time.

And one's perception of art in a museum is also about 'milliseconds'.

135

Yes. And even contemplating a work of art for many years is no different.

Besides these fifty pairs, there was also the series of enamels from 2010 called *Perizade,* displayed at the Marian Goodman Gallery in Paris in 2011.[18]

Yes. All the reverse-glass paintings have a fairy-tale feel, which is why I named them after stories in *One Thousand and One Nights*: *Aladdin*, *Abdallah* and *Perizade*. All of them are wonderful tales. Beautiful and cruel.

The thing that interests me in these is the contrast to oil painting or any other form of painting on canvas or wood, which are physically very robust and can last for hundreds of years. By comparison, the enamel paintings behind glass are incredibly fragile. If one breaks, it can never be restored. They are extremely vulnerable, and you can feel that, as a viewer, when you're looking at them.

Yes, that's true. Like all glass objects.

How did the book *Sindbad* come about? I know it took some years. At times, you toyed with the idea of asking certain authors to write texts, but then that idea was abandoned. Ultimately what did come about...

... perfectly suited me: I used an existing text that had no immediate connection to the images. It's the story of Sinbad the Sailor, and the images are only related to it obliquely; that's to say, the text doesn't discuss the pictures and the pictures don't illustrate the text.

Exactly – just like your very first artist's book, the *Perry Rhodan* catalogue you made with Polke in 1966. There's so much already in place in that catalogue: the text-image situation, readymade text and so on. And the way *Sindbad* is printed almost makes it look like a facsimile of some kind.

We took a great deal of trouble over it, because we were determined to make a particularly good job of the printing process.

And the cover has a kind of banner across the lower section, which is already the beginning of the text.

Yes, I rather like it that the first tale already starts on the outside of the book.

And you were also involved in deciding on the paper?

Yes. It's very sumptuous, a perfect match.

It works well with the original paintings. It creates similar, irresistible colour effects. And it also makes this one of your most sensuous books; somehow you find yourself touching these saturated colours on high-gloss paper in a special way. At the same time that you were working on *Sindbad* and the paintings, you also started on *Patterns: Divided Mirrored Repeated,* although *Patterns* came out in 2011, after *Sindbad*. That's why it's interesting that in the Marian Goodman exhibition in Paris, the enamel paintings, the *Strips* and the reverse-glass paintings were seen together for the first time. It's interesting because there were two different things happening at once, and both had to do with chance. Your next artist's book, *Patterns*, is also your largest-format book to date. What prompted you to start working with patterns?

It would never have happened without Joe Hage. He had bought the painting that triggered the patterns a long time before that at an auction. He wanted to make a poster from it, and he did, in fact, produce a blurred edition. Then, when I was playing around with various prints from that edition and different patterns were emerging, he immediately had a tapestry woven from what I'd done. After that my interest was aroused, and so, over the years, the *Patterns* book came about.

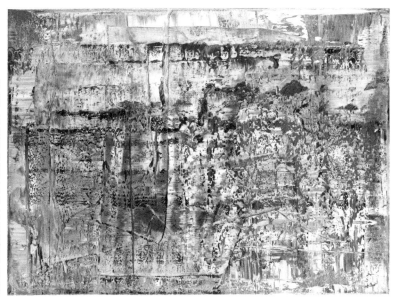

Abstract Painting [CR 724-4], 1990, oil on canvas, 92 × 126 cm

The painting Joe Hage bought was *Abstract Painting* of 1990, which is also reproduced at the beginning of the book?

Yes. I think Peter Gidal owned it before Joe; he certainly analysed it very well in one of his texts.[19]

And tapestries were also made from that painting?

Yes, with four-way reflections, left/right and above/below, like an emblem. There are four different tapestries altogether.

And they're in your catalogue raisonné?

In the catalogue raisonné of editions.

And was it the tapestries that led to the book?

Yes, albeit slowly and not very smoothly. I was fascinated by the way that the lateral reflections and repetitions produced countless patterns – without any input from me; that's to say, better than anything I could have come up with, simply by means of a system.

And the system is revealed straight away at the beginning of the book. In other books, like *War Cut* or the little Insel book, it was implicit that there was a definable system, but at the same time there was a strong sense of Tristan Tzara's 'the best system is no system'. By contrast, in *Patterns*, everything is suddenly very systematic, and even the smallest details of the system are perfectly clear. And as you say in the title of the book, the original painting has been divided, mirrored, repeated.

Yes, theoretically the patterns could go on for ever.

And that's actually just as extreme as in *Sindbad*; you can imagine it going on *ad infinitum*.

You can imagine it. Luckily, reality, which limits everything, steps in. And now in the larger *Strip* paintings I've noticed that, little by little, conditions are arising – not just practical factors concerning technique, size and weight, but aesthetic considerations that then become the basis of distinct criteria, value judgements. And that's exciting. At last we've regained our old uncertainty. [*laughs*]

And you can't even see the patterns any more in the most recent *Strip* paintings; the details are on such a small scale

that they just look like lines of colour. They look all the more unfathomable, mysterious, and convey a sense of unbelievable acceleration. It's not to do with Bridget Riley or Op art; those paintings are much closer to Futurism and Umberto Boccioni.

And Minimal music.

Boccioni meets Steve Reich! If you look at them for any length of time your head starts to spin.

Especially if you've had something to drink. Whatever the case, it's pure retina painting.

You also once had the idea of making very large *Strip* paintings: would they somehow be related to the vast spaces you once devised in *Atlas*? Mega-paintings in mega-interiors?

That was almost fifty years ago, and those sorts of fantasies are certainly best confined to *Atlas*. It would be dreadful if they were ever realised. So there's absolutely no doubt that the *Strip* paintings will never go down that route. The normal formats are already quite exciting enough for me!

Benjamin Buchloh wrote about the *Strip* paintings for the Paris catalogue: 'Richter's immense quantificatory expansion reaches the threshold of the negative sublime in the form of a purely technocratic enumeration and quantification that is laconically presented as a collectively determining and controlling condition, one no longer invested with any political or social hopes for utopian transformation within the sphere that was once conceived as public.'[20]

I'm looking forward to reading that in German; I can't understand a word of it in English.

It is extremely complicated. He also describes the paintings as 'harsh' and 'immediate' – the latter is certainly true. Each of these works has without doubt a very direct, immediate 'millisecond' impact. But is it harsh?

Perhaps in the sense of the cold, because of their perfection.

Yet they're also extremely seductive. Now, the question is, should we include *Night Sketches* from 2011 in our discussion? Is it an artist's book? Surely it is, really.

139

It was just a little notebook that I sometimes used to scribble things in at night. Then Joe Hage saw it one day and straight away wanted to print a facsimile. So it wasn't my idea – but I did oversee the design process.

Gerhard Richter
Night Sketches

HENI PUBLISHING, LONDON 2011

Cover of *Night Sketches*, published by HENI Publishing, London, 2011

It was printed the way you wanted, so it's an artist's book. Could you call the images insomnia drawings?

They're not as weighty as that – much more harmless. That's to say, sometimes if I can't sleep, I read or make some notes or little sketches, just like that, with no rhyme or reason. That's probably why they can seem quite appealing to me in daylight.

So now we should talk about *Atlas*. It's interesting how much of what is in the artist's books is also in *Atlas*, such as the layouts for *War Cut* or the details for *Halifax* – often all the material for your artist's books subsequently found its way into *Atlas*. It's like the book of books, the meta-book. Would that be right?

Yes, it would. Not the catalogues for it, but *Atlas* itself.

But even the first catalogue for *Atlas* – just a little publication for the show in Utrecht in 1972 – was already something of an artist's book.[21] Then there was the large-format volume for the Lenbachhaus in 1997[22] and the new edition published in 2006.[23] You once said to me that that was now more or less the final form.

Yes, but now we're already planning a new one.

Really? But before we come to that, I'd like to return to *Atlas* in its present form. How did that collection arise?

I always had a lot of photographs, concepts and sketches for paintings that I couldn't hang in galleries or sell as autonomous works. But it seemed too much of a shame to throw them away. They had documentary value, so I turned them into this in-between thing: *Atlas*.

And then it happened that that was sold to a museum. It's very unusual that a museum buys a work that subsequently continues to grow. I remember, once when I was in your studio in the 1990s, that you had just put together another bundle of items to send to Munich. It's a work that's constantly evolving, you might say with no end in sight.

Of course, I was naturally very happy at this chance to entrust part of my work to others to look after.

And what about the format of that book? You tried out a number of very different formats. The big Munich catalogue in 1997 was rather like a real atlas – the way you'd imagine an atlas. But the new edition is much more compact.

I much prefer it, of course. It's much easier to handle than a big, fat book that's always too heavy for comfort.

Did you devise the layout?

I think so, yes.

So that means *Atlas* is another of your artist's books...

Yes, that's right.

And its present form is not its final form?

No, Helmut Friedel and Walther König have yet another idea: a lot bigger and differently arranged. But I'll only be a consultant for that one.

The great thing about your artist's books is that there's always something new in the offing. And as we speak, a new artist's book is already under way, a small version of *Patterns*.

Yes, at first I felt that *Patterns* would only work as a large format and that it would be silly to make a small edition. But when I saw it with my own eyes – a mock-up, made by hand just for fun – I was immediately persuaded that it would be perfectly possible to publish it like that. It's also about the price – anyone could afford the little one.

An everyman's *Patterns*.

Yes.

It's the same as Gilbert & George's idea of 'Art for All' – that you can make art for anyone. That's also closely connected with the book as an artistic medium. Because the book is in fact a very democratic medium. It's the only work of art that anyone can afford.

That's how it's intended.

Specifically in the case of *Patterns*, you had the idea from the outset that it should also be read outside the confines of the art world. You wanted it to have a potentially much wider relevance for graphic artists, designers and so on. You once said that it could be used as a real pattern book, by people designing consumer goods, clothing and so on.

Yes, a pattern book for the textiles industry – that would be fine by me. [*laughs*] Joe said there had been enquiries. But as far as I am aware no one's asked – at least no one's approached me. As yet, no one has wanted to use my *Patterns* to produce a shirt.

So the idea of merchandising hasn't come to anything?

As yet! But you never know how an idea of that kind might suddenly take off.

Are there any plans for more, different versions of that book? The patterns have so much potential as books, because there are so many variations. And then there are also all the studies you have done. It would be very possible to make more books on that subject – or do you feel that there won't be any more books on that theme?

It wouldn't be fun any more. As it is, this contains only a fraction of all the various possibilities. There are only twelve illustrations of examples of the division into 4,096 strips. But you can't have a chapter that is four thousand pages long – the book would then be over ten thousand pages long and still not nearly contain everything. It would be a monstrosity.

We still have to talk about your most recent book, *November*, published this year. You once said you were at the point of abandoning that book. When we were working on our book *OBRIST/O'BRIST*, there was also a time when you wanted to throw it all out, but then you solved the problem by including text passages.

I didn't want to discard the *November* book, only the twenty-seven ink drawings; they seemed too facile to me. I found myself wondering what I was playing at. But then I kept them after all.

And what made you decide to make a book?

When I started making reverse-glass paintings, I tried out Edding and other inks on a sketch pad and was astonished at the fantastic forms and images appearing on the paper, because these inks soaked through the paper and you could also accept the backs of the pages as they were, or develop them further. So then there were fifty-four recto and verso images, twenty-seven sheets in total. There was something intriguing about them – but it took a while before I decided to go with it and signed them. It was a bit like what happened with my 1957 series, *Elbe*...

... and also a bit like the drawings of Victor Hugo – somewhere between *Elbe* and Victor Hugo.

Yes, exactly. Some of the Victor Hugo drawings have very nice titles. In any case, there's almost always an element of chance in my paintings, and I like unexpected bonuses. I have the feeling that these paintings are all bonuses. It's the same feeling you have when you're developing photographs in the darkroom – like being given something for nothing – or when you find a photograph in a newspaper.

And the pictures were just lying around?

They were in a cupboard. I had often looked at them and wondered whether I should throw them out or not. But then Joe had the idea of making a book from them. The problem was, how could they be shown in an exhibition? You would either have to show the front or the back of each sheet. And you would have to fix them to something. We had the same problem with *Elbe*, although

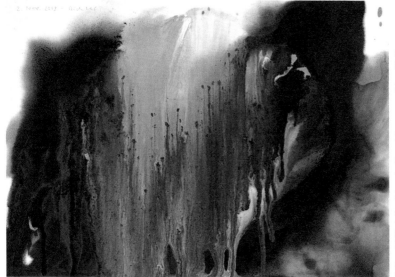

2. Nov. 2008, Indian ink and white spirit on paper, 21 × 29.7 cm

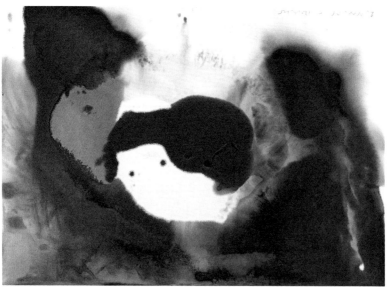

2. Nov. 08, Indian ink and white spirit on paper, 21 × 29.7 cm

in that case there were only seven sheets that had recto and verso images. As it turned out, [for *Elbe*] we just made facsimiles and of course no one noticed. When I went to Paris for the exhibition at the Louvre,[24] I took fifty-four *November* facsimiles with me and I told the curator, Marie-Laure Bernadac, that they were all facsimiles, to which she said, 'You're joking!' She couldn't believe it.

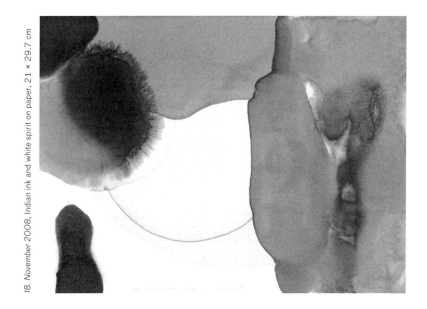

18. November 2008, Indian ink and white spirit on paper, 21 × 29.7 cm

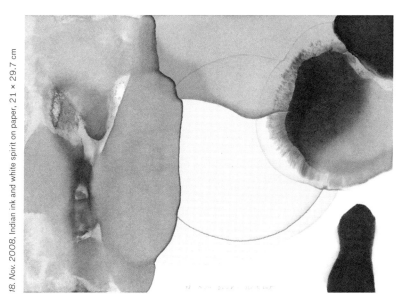

18. Nov. 2008, Indian ink and white spirit on paper, 21 × 29.7 cm

Things are very different these days; we have such perfect reproduction technology that it's often impossible to tell the original from the copy.

That's very interesting, because you and I have been talking about facsimiles of pictures for a long time now, and whether

145

there could be a facsimile museum. Only you were never really happy with any of the facsimiles of paintings. But in this case it worked perfectly.

Yes, because they were like prints. But when a facsimile is trying to look like an oil painting and you go up close to it, you're just disappointed, because it doesn't have the same texture as paint that has been applied for real.

And in the case of *November*, the book allows you to see the sheets in a way that you could never see them in an exhibition – you can see the backs and fronts of all of them.

Exactly. In an exhibition you have exactly the same images, it's just that the two sides are separated.

And what is the next book? We've already mentioned the new version of *Atlas*...

There won't be any more books, that's over and done with. [*laughs*]

[*laughs*] But that was also the big thing when we were working on *Writings and Interviews*. You've always said that the trouble with that book is that you stopped writing after that.

Right, yes, I see what you mean. It was a bit like that with *Atlas*, too. Once it was published, I didn't really feel like it any more.

My anxiety is that when we publish this book about your books [*Gerhard Richter Books: Writings of the Gerhard Richter Archive Dresden*], that'll stop you wanting to make any more books. That would be dreadful.

Well, I'll just have to forget all about it, which shouldn't be too hard at my age...

That's a comfort! So there *will* be more – I'm already looking forward to the next book.

Me too. [*laughs*]

1 Dieter Schwarz, *Gerhard Richter Books: Writings of the Gerhard Richter Archive Dresden,* (New York: Gregory R. Miller & Co, 2014), pp.33–110.

2 Karl-Otto Götz (1914–2017) was a German artist associated with the Informel movement. Götz was a professor of art at the Kunstakademie Dusseldorf, Germany.

3 Klaus Honnef, *Gerhard Richter*, (Aachen: Zentrum für Aktuelle Kunst, 1969).

4 Jürgen Harten (ed.), *Gerhard Richter: Paintings 1962–1985*, (Cologne: DuMont, 1986).

5 Suzanne Pagé, Wenzel Jacob, Björn Springfield, Kasper König, Benjamin Buchloh, *Gerhard Richter: Catalogue Raisonné 1962–1993*, (Ostfildern-Ruit: Hatje Cantz, 1993).

6 Dieter Honisch, *Gerhard Richter: Graphics 1965 to 1970*, (Essen: Museum Folkwang, 1970).

7 *Gerhard Richter: Panorama*, Tate Modern, London, UK, 6 October 2011 to 8 January 2012.

8 'We asked him if he could contemplate a new publication of these details as a book. He agreed and from time to time over the following months he revisited the photographs, had new prints made, and redefined the details, until this work came to fruition in the summer of 1998 as an autonomous book.' Ibid., n.p.

9 Bruno Corà, *Gerhard Richter*, (Rome: Galleria Pieroni, 1980).

10 Hanne Darboven (1941–2009) was a German Conceptual artist.

11 *Gerhard Richter: Painting 2010–2011*, Marian Goodman Gallery, Paris, 23 September to 3 November 2011.

12 Birgit Pelzer, *Le Désir tragique: Sur Gerhard Richter*, (Paris: Les Presses du Réel, 1993).

13 'A sort of cross between a litany and a *puja*, such veils are both arbitrary and accidental; they have no meaning in themselves, but can be used as a tool to extract meaning elsewhere. What we do with them and what we learn from them must depend upon ourselves.' Anne Seymour in *Gerhard Richter: Stammheim,* (London: Anthony d'Offay Gallery, 1995), p.60.

14 Hans Ulrich Obrist (ed.), *The Daily Practice of Painting: Writings and Interviews 1962–1993*, (London: Thames & Hudson and Anthony d'Offay Gallery, 1995).

15 [CR 648-2] at Musée d'Art Moderne de la Ville de Paris.

16 *4900 Colours* [CR 901], 2007, lacquer on Alu Dibond, 680 x 680 cm. Composed of 196 panels – each of which is comprised of twenty-five squares – that can be arranged in eleven different configurations.

17 Jeanne Anne Nugent, 'Interview with Gerhard Richter' in Ulrich Bischoff (ed.), *From Caspar David Friedrich to Gerhard Richter: German Paintings from Dresden*, (Los Angeles: J. Paul Getty Museum, 2006), pp.113–17.

18 *Gerhard Richter: Painting 2010–2011*, Marian Goodman Gallery, Paris, 2011.

19 Peter Gidal, 'Endlose Endlichkeit' in *Gerhard Richter* (1993), vol. 2, pp.99–103.

20 Benjamin H. D. Buchloh, 'Painting Progress, Painting Loss' in *Gerhard Richter: Painting 2010–2011*, (Paris: Marian Goodman Gallery, 2011), pp.23–9.

21 *Gerhard Richter: Atlas van de foto's en schetsen*, (Utrecht: Hedendaagse Kunst, 1972).

22 Helmut Friedel and Ulrich Wilmes (eds), *Gerhard Richter: Atlas der Fotos, Collagen und Skizzen*, (Munich: Städtische Galerie im Lenbachhaus; Cologne: Oktagon, 1997).

23 Helmut Friedel (ed.), *Gerhard Richter: Atlas*, (Munich: Städtische Galerie im Lenbachhaus; Cologne: Verlag der Buchhandlung Walther König, 2006).

24 *Gerhard Richter: Drawings and Watercolours 1957–2008*, Musée du Louvre, Paris, 7 June to 17 September 2012.

The Impossibility of
Absolute Painting
1993

A Still Picture
1995

The Shape of
the House
2005

Nothing Works
Without Faith
2007

Like Bright Dust
and Fog
2007

A Distorted Form
of Legibility
2011

Grey in Several
Layers
2014

'Grey in Several Layers' was conducted in February 2014 at Richter's studio, to coincide with the monographic exhibition *Gerhard Richter: Pictures/Series,* curated by Obrist at the Fondation Beyeler in Switzerland. The exhibition and conversation focussed on Richter's series, cycles and interior spaces. Comprising some hundred paintings — Grey Pictures, Photo Paintings and Abstract Paintings — along with two glass objects and sixty-four Overpainted Photographs, the exhibition encompassed the major periods in Richter's career since 1966. The interview was published in the accompanying exhibition catalogue.[1]

While I was preparing for our conversation about your series, cycles and interior spaces, I took another look at your books. It struck me that your interest in the relationship between images and their surroundings began very early on. It goes back to your days as a student in Dresden – before the catalogue raisonné of your work begins – when you designed murals in 1955 and 1956 for the dining hall of the Academy of Fine Arts and for the Museum of Hygiene. Your intensive engagement with interior spaces began in 1970: your *Atlas* contains a large number of designs for them dating from that year and the next. They show mainly imaginary architecture, but sometimes also real architecture, in which your pictures might be displayed.

RICHTER I've always enjoyed drawing plans – for apartments, for example, or for houses, though I never dreamed of ever being able to build them myself.

And later, in 1971, you designed real high-rises.

That was actually meant seriously. They were designs for state-subsidised apartments on the Rheinwiesen in Dusseldorf, with units stacked on top of one another to form high-rise buildings. The roof of one formed the garden of the next.

So was that a proposal that could have been implemented?

Well, I'm not an architect, you know.

The proposals for presenting your pictures feature both very monumental interiors and small, almost minimalist rooms. And then there are rather classical-looking spaces. The pictures on sheet 252 in the *Atlas*, for instance, recall panelled wall decorations in palace interiors. And some of the other designs, like those of sheet 251, look a bit like stage sets or diorama images.

I wanted to find out what happens when pictures are staged, if it's possible to increase their effect and, if so, how and with what motifs.

Most of the paintings in these spatial concepts are clouds or landscapes. Why those of all things?

151

Maybe it was connected with the fact that, at the time, traditional subjects were really looked down on, especially if they were done in oil on canvas. It was a kind of act of defiance on my part. And I derived some support from the work of Gilbert & George. There was something nostalgic about it, something neoclassical.

On sheet 222, the cloud and landscape pictures have suddenly covered the floor and ceiling as well as the walls.

That was the 'total picture' that I talked to Sigmar Polke about in a fictional interview with him in 1964. We discussed pictures so overwhelming in effect that they could have been used to torture or kill and so weren't allowed to be shown again in public.

There are also designs for spaces so huge that the people look as small as ants and the pictures appear even bigger and even more threatening.

That was wishful thinking, or pleasure in provoking and opposing, because at that time there was a general move to reduce barriers, plus a certain degree of scepticism towards the sublime. Cologne Cathedral wasn't allowed to have steps any more, which is why there's this ugly square in front of it. And the Haus der Kunst in Munich was supposed to be demolished because it was fascist.

Your 1975 design for a museum looks like an administration building or a barracks and was intended to have a thousand rooms...

... for a thousand Grey Pictures. Pretty absurd! It started with *Eight Grey* now in Museum Abteiberg in Mönchengladbach. The idea was to hang the same picture in all the museum's galleries. A thousand times or more – permanence for all eternity. The end of painting.

The never-ending end... And along with these designs for imaginary spaces that explored various forms of presentation there were the first real spaces, for exhibitions. In 1971, you collaborated with Blinky Palermo. How did you get to know him?

When Palermo arrived at the Art Academy in Dusseldorf, Konrad Fischer said to me, 'Look at it – it's really good.' At that time, Palermo was studying with Bruno Goller. Later, he was with Joseph Beuys. Palermo had a feeling for aesthetic quality, more than the others. His things were very quiet. I liked that a lot.

So it was possible to talk to Palermo about the quality of pictures?

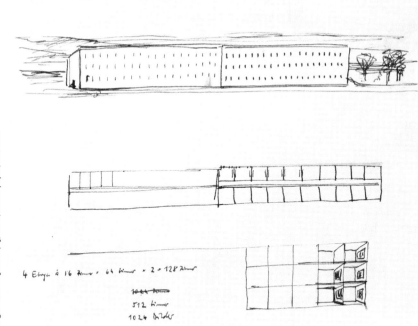

Museum (Barracks or Administration Building) for 1000 Large Pictures [CR 75/1], 1975, ink on paper, 21 × 29.7

4 Etage á 16 Räume = 64 Räume × 2 = 128 Räume

~~1024 Räume~~

512 Räume

1024 Bilder

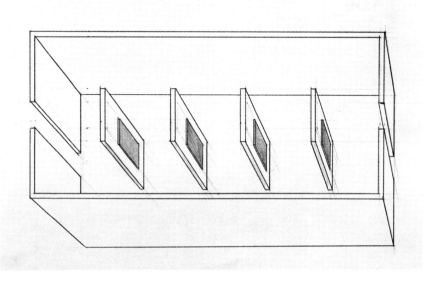

Study for the Presentation of 'Grey Pictures' [Drawings CR 75/3], 1975, ballpoint pen and graphite on paper, 21 × 29.7 cm

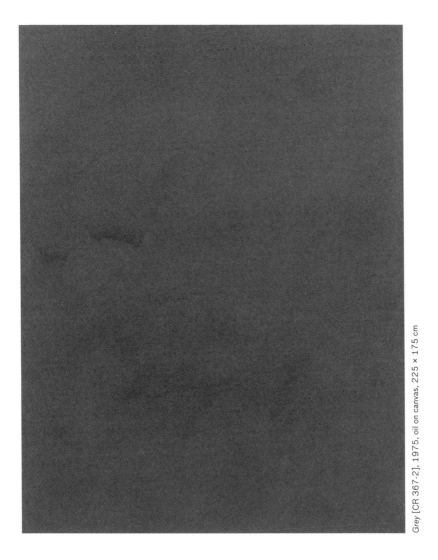

Grey [CR 367-2], 1975, oil on canvas, 225 × 175 cm

Yes, that's what we were always talking about, really. That was less possible with Polke. It was actually easier with Konrad Fischer, who made judgements very quickly: 'That's good' or 'That's no good'.

It was about judging things?

About judging things, yes. It's the most important capacity we possess. Another reason I got on well with Palermo was that he had an interest in nostalgic or classical aspects. Our exhibition at Heiner Friedrich's gallery in Cologne, where I showed *Two Sculptures for a Room by Palermo*, was

a typical example of that. The room had a kind of sacred aura, and that was almost reactionary – it opposed the zeitgeist, which demanded social relevance.

Was part of the appeal that you were operating with bronze heads?

Yes, this old-fashioned material in a vaguely classical space – it had an element of the sublime about it. A year before, we had done the exhibition *For Salvador Dalí* together at the Galerie Ernst in Hanover. A single picture hung in each of the two rooms, with a black strip running around the walls just below the ceiling. That looked very beautiful, and it was meant to.

And your two pictures were abstract?[2]

Yes, done after close-up photos of a palette smeared with paint. A bit too Dalí-like, elegant.

You and Palermo didn't like Dalí?

We found him much too theatrical. But we objected to the arrogance with which he was being written off.

Were there other projects with Palermo, realised or unrealised?

In [gallerist] Six Friedrich's living room, we painted a grey shape on the wall around the window. It was a bit like an oil painting we had done before, in which each of us painted one half with his fingers.

Along with the imaginary spaces in *Atlas*, there are ones based on actual sites. In these, existing spaces prompted the work, as they would later in your Art for Architecture projects and your installation at the Deutsche Guggenheim in Berlin in 2002.

It makes a lot of sense to prepare an exhibition as precisely as possible using a model. In 1971, I had my first major retrospective, at the Kunstverein in Dusseldorf, and that was the first time we thought the design so important that it should be reproduced in the catalogue.

So the Dusseldorf exhibition was one of the first designs for displaying your work actually to be carried out?

Yes, and then the German Pavilion at the Venice Biennale a year later.

That's where you showed *48 Portraits*, one of your first cycles of pictures, and one of the largest. You produced the cycle specially for the pavilion and you...

... gave it a fully-fledged staging there.

In the central room of the pavilion, which you must therefore have fully approved of.

Yes, it was already there. I liked its proportions, and its denigration as a Nazi pavilion didn't interest me. It's an almost uniquely well-suited exhibition space.

The cycle itself has a certain ambivalence. On the one hand, it consists of encyclopaedia illustrations with a unified appearance and, in that sense, it's very standardised. At the same time, though, these are people whose achievements as individuals have been historically important – people like [Rainer Maria] Rilke, [Igor] Stravinsky and [Albert] Einstein.

That's exactly what I found so appealing, the fact that the portrait format reveals very little, so that the mind and imagination have to contribute a lot. It's the same with *Eight Student Nurses*, in which the pictures give no clue that the young women have been murdered. The title suggests that, as does the instruction leaflet and the manner of the staging.

Eight Student Nurses [CR 130], 1966, oil on canvas, eight parts, each: 95 x 70 cm

Annunciation after Titian [CR 343-1], 1973,
oil on canvas, 125 x 200 cm

Annunciation after Titian [CR 344-2], 1973,
oil on canvas, 150 x 250 cm

That's not the case with the five paintings *Annunciation after Titian*, in which a narrative is perceptible.

That's probably why I wanted to copy it. I saw it in the Scuola Grande di San Rocco in Venice and I just wanted to have it, at least as a copy. I didn't succeed; I couldn't have succeeded, because that whole marvellous culture has gone. All we can do is to come to terms with that and make something out of it nevertheless.

157

You once said that a very important motivation for painting is to convey a message.

The Virgin in that painting is being told that she'll have a child.

That's the picture's content, its message.

Yes. We're always wanting to communicate something, even if it's our doubts or our despair. Whatever it is, it will come out.

The idea of conveying messages is interesting in view of all the talk about the end of painting. You've always denied that. After all, even an interior with Grey Pictures, like the one in the museum in Mönchengladbach, has a message. Could you say something about how the series of Grey Pictures began?

It started with Abstract Paintings that just became more and more grey, and with photo pictures, which I blurred until there was nothing left to be seen but grey. But then I noticed there were qualitative differences among them, and that's when it started to fascinate me. Why was one Grey Picture good and another less good or less bad, and so on?

So it became possible again to make judgements, to distinguish good from bad.

Yes, and the most important thing for me at the time was that I recognised that however negative or destructive the origins of a picture might be, the end result can be entirely constructive – that is to say, as a picture that comes across as very beautiful, serious, consoling, which is beneficial.

And then, in 1975, you also painted the eight large *Grey* pictures.

Yes. Grey in several layers, one picture after another. I wanted each one to look like its predecessor, but better – which isn't possible, of course.

You told me how moved you were when the eight pictures were installed in Mönchengladbach, because that was the first time a gallery in a museum had been given over to your work in a permanent display designed by you.

That was a big thing for me. Johannes Cladders, the director of the Museum Abteiberg, came to my studio, saw *Eight Grey*, and said, 'I'll buy the flush. I want to have that.' Then they got a room of their own in the newly occupied museum building, which they still have.

That brings us to the *October 18, 1977* cycle. I remember being in your studio in the late 1980s. You'd gathered together a large number of photos relating to Stammheim prison and the Baader-Meinhof Gang. You thought about the subject for a long time, then it began to take shape more and more clearly. But in the end, the cycle wasn't prompted by a specific event, was it?

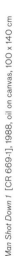

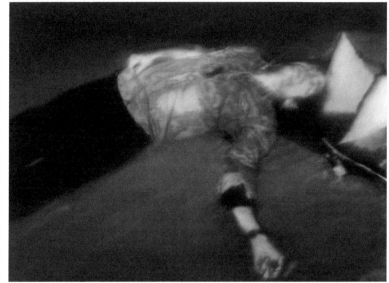

Man Shot Down 1 [CR 669-1], 1988, oil on canvas, 100 x 140 cm

Well, there was a development towards it. The first thing was that those of us who came from East Germany were initially happy to be here in the West. We were amazed at the freedom here. Then along came the so-called 1968 generation and started saying there was no freedom here and everyone was a fascist. I'd come from a quasi-fascist state, so I was shocked to see how much support they got, how powerful belief can be, conviction. Incidentally, that is an interesting word: it comes from the Latin '*con*' (signifying completeness) and '*vincere*' (to conquer).

One thing I've noticed about your series or cycles is how variously they define the relationship between individual components and the series as a whole. Some of them need to stay together. The *October 18* cycle, for example, forms an indivisible unit. The *Cage* paintings, too, constitute an ensemble of their own. But with *Annunciation after Titian*, for instance, the paintings have been dispersed among various collections and are often shown

separately. They do work on their own, but they acquire special significance when seen together as a group. Why didn't the Titian paintings stay together?

It was partly a matter of convenience and compliance, of course. But apart from that, I've always disliked it when artists make stipulations. And it's not really a bad thing if pictures are dispersed – they often come together again in exhibitions and in the catalogue anyway. Of course, there are series or cycles that should stay together – the *Cage* and *October 18* pictures, for example, or *Forest* and others of that kind.

Pictures have a life of their own. It's like children leaving home when they're grown-up… We ought to talk about the series featuring Abstract Paintings. You started producing large Abstract Paintings in the early 1980s. The abstract cycles are often united by a common theme, a shared title. How are they motivated? How did *January*, *December* and *November* come about, for example?

That's difficult. At first, there's just a vague itch, which then morphs into an actual wish to start something in this or that size, colour or number. And then I begin, usually with ideas that eventually come to nothing. That's because, as the pictures emerge, they themselves decide more and more clearly in what direction they want to go, how they want to look, how they want to be. That's only half true, of course, but it's the more important half. I notice it particularly when I reckon I've thought of something interesting – it always turns out to be wrong. All the white pictures of 2009 that I exhibited with Marian Goodman in New York[2] started out brightly coloured, mainly in green. They underwent an extreme transformation.

You often produced the multiple works and groups of works of Photo-Realistic pictures one after another, as with *Eight Student Nurses* and *48 Portraits*. Is the working process similar with the Abstract Paintings?

No, not at all. Whether there are three pictures or twelve, I work on them all at the same time. At any given moment, they've all progressed to the same extent. And every change on one canvas prompts a change on the others. Until they're all ready at once.

You once told me that the *Forest* cycle had less to do with depicting a forest in concrete terms than with feelings of helplessness.

Yes. Helplessness is the great theme in painting, or rather the strongest motivation for and during painting. And the forest in general has special

significance, perhaps more so in Germany than anywhere else. You can lose your way in forests, feel deserted, but also secure, held fast in the bosom of the undergrowth. A fine romantic subject.

For our exhibition at the Fondation Beyeler, you had the idea of hanging single works in the galleries as a counterpoint to the series and cycles. Had you done that before in a show?

In 1984, when Kasper König put on *From Here* in Dusseldorf, I showed two rows of Abstract Paintings, both interrupted by a small landscape. That was very effective, not only because of the contrast, but also because it made you look differently at the two halves. It established a connection between the two that enriched both.

At the same time, it could be said that this interplay between single image and series is a constant presence in your work. Basically, you're always working on series. Then occasionally you paint these incredible single pictures that have the character of a unique masterpiece. It's really very mysterious because the creation of a masterpiece can't be planned.

That's right. Because it has something to do with luck. That applies not just to the representational pictures – the abstract ones can also have that kind of quality. But of course you have to disregard the fact that the term 'masterpiece' can't really be used any more. It would have to be redefined. The skill that once produced masterpieces no longer exists.

We've reached a point in the art world at which everything is getting bigger and bigger. Museums are becoming increasingly monumental.

And works are getting bigger and bigger, too, and especially bigger in numbers. There's never been so much art before.

And yet small pictures can have a quality and perfection that large formats can never achieve.

Yes, big pictures come straight at you, domineering and intimidating. Small works can inspire much more love.

Like *Betty* [p.19] and *Small Bather*. That's why it's good that we've also got small pictures in the exhibition here at the Fondation Beyeler. One of the first times we showed a large selection of pictures with portraits of members of your family in an exhibition was in 1996, at *100 Paintings* in Nîmes. At the time, there was

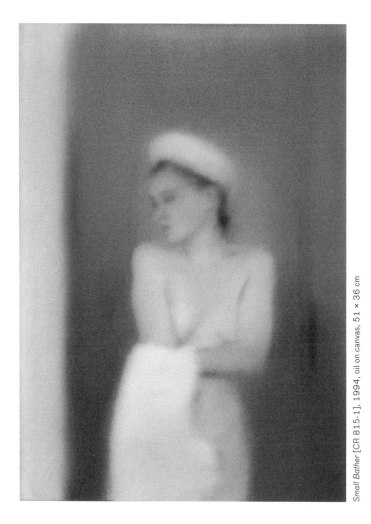

Small Bather [CR 815-1], 1994, oil on canvas, 51 × 36 cm

a very wide-ranging discussion about the family portraits. Now, twenty years later, the pictures are even better and are constantly recharging themselves. Family pictures formed part of your oeuvre early on, beginning in the 1960s. But in the 1990s the mother-and-child picture developed into a cycle of its own, *S. with Child*. How did that come about?

Well, you know, it's really the most natural thing in the world to do pictures of events that move us. It's acceptable to take snapshots of them, but there's almost a taboo on painting them.

But you painted them nonetheless.

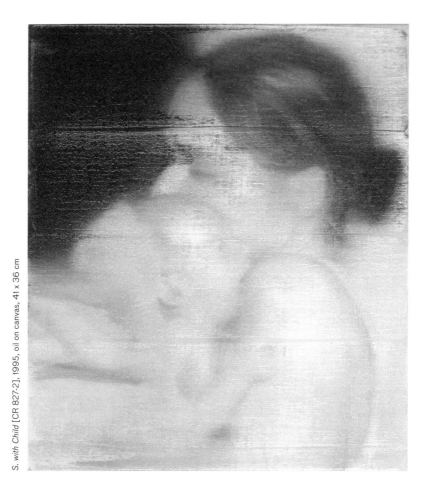

S. *with Child* [CR 827-2], 1995, oil on canvas, 41 x 36 cm

Yes, and the dilemma is apparent in the pictures.

'Images in spite of all', to quote Georges Didi-Huberman.

Beauty has gotten such a bad name partly because so much ugly stupidity has been put across as beautiful. The whole cult of role models to be imitated, propagated by the cinema, TV and magazines, presents a beauty that's mendacious and brainless, and maybe that's why ugliness is so very hip. Society is anaesthetising itself.

Another taboo, if you like, similar to that on images of a mother and child, applies to flower paintings. But still lifes have something timeless about them.

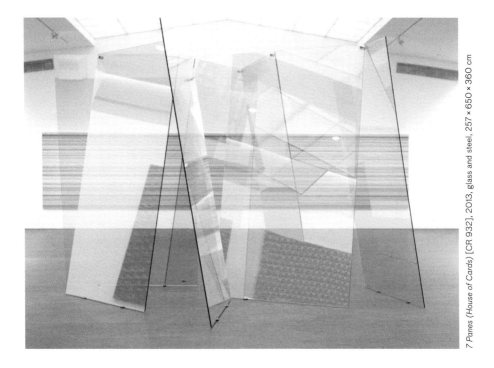

7 Panes (House of Cards) [CR 932], 2013, glass and steel, 257 × 650 × 360 cm

That would be wonderful.

> In our exhibition here, along with the two large glass objects
> *12 Panes* and *7 Panes* (*House of Cards*), both from 2013,
> you're showing four large Double Grey Pictures. These date
> from 2014 and are the most recent works in the exhibition.
> Were they created especially for the Fondation Beyeler?

Not exactly, because I designed them on a similar scale for a permanent
installation in Japan. There, they were meant to be installed at a height of
four or five metres, so that they weren't facing viewers, but were far above
them, facing each other on four walls of a square room.

> You had already occasionally shown your pictures at unusual
> heights – *Eight Student Nurses*, for example, and particularly
> *48 Portraits* in Venice.

Yes, but here the pictures were not meant to be seen at all. I had sketched
this weird idea about forty years before. The drawing shows a Grey mono-
chrome picture hanging opposite a mirror of the same size in a small room

that's cordoned off, so the ensemble can be seen only from one side and the viewer is excluded from it.

That sounds ridiculous.

Sure, but the drawing always stayed with me, like when I read a year ago about a piano piece by Bach, that it's the kind of music that's so perfect it has no need of us.

So it lives outside us?

Of course that's ridiculous, but I'm fascinated by the idea that art can come close to a quality that makes it independent of us.

Like God?

Yes – art has a great deal to do with that.

1 Hans Ulrich Obrist (ed.), *Gerhard Richter: Pictures/Series*, (Riehen/Basel: Fondation Beyeler, 2014) pp.92–101.

2 *Gerhard Richter: Abstract Paintings*, Marian Goodman Gallery, New York, 7 November 2009 to 9 January 2010.

Gerhard Richter was born in 1932 in Dresden, Germany. He studied at the Dresden Academy of Fine Arts and the Dusseldorf Art Academy. Richter's work has been the subject of exhibitions internationally, including touring retrospectives organised by the Kunsthalle Dusseldorf, Tate, London and the Museum of Contemporary Art Chicago, among many others. Working in a variety of mediums – namely sculpture, photography, drawing and, notably, painting – the artist continually examines the nature of imagery and representation in his work.

Hans Ulrich Obrist was born in 1968 in Zurich, Switzerland. Obrist is Artistic Director of the Serpentine Galleries, London. Prior to this, he was the Curator of the Musée d'Art Moderne de la Ville de Paris. Obrist has curated more than 300 exhibitions internationally since his first, *World Soup (The Kitchen Show)*, in 1991.

Acknowledgements

I am deeply grateful to Richter for our long-standing friendship and from whom I have learnt so much. I would also like to express how thankful I am to Joe Hage for his friendship, his vision as a publisher and for making this project happen, together with Jacky Klein, Phoebe Adler and everyone else in the amazing HENI team. I would also like to express my deepest gratitude to Sabine Moritz-Richter, who took the photograph for the book's cover.

Hans Ulrich Obrist

Monographs

Dietmar Elger, *Gerhard Richter: A Life in Painting*, (Chicago and London: University of Chicago Press, 2010)

Dietmar Elger (ed.), *Gerhard Richter: Catalogue Raisonné, Volume 1–6*, (Ostfildern-Ruit: Hatje Cantz, 2011–19)

Dietmar Elger and Hans Ulrich Obrist (eds), *Gerhard Richter Text: Writings, Interviews and Letters 1961–2007*, (London: Thames & Hudson, 2009)

Mark Godfrey and Nicholas Serota (eds), *Gerhard Richter: Panorama: A Retrospective: Expanded Edition*, (New York: DAP, 2016)

Jürgen Harten, *Gerhard Richter: Paintings 1962–1985*, (Cologne: DuMont, 1986)

Hans Ulrich Obrist, *Lives of the Artists, Lives of the Architects*, (London: Penguin, 2016)

Hans Ulrich Obrist (ed.), *Gerhard Richter 100 Bilder*, (Ostfildern-Ruit: Hatje Cantz, 2008)

Hans Ulrich Obrist (ed.), *The Daily Practice of Painting: Writings and Interviews 1962–1993*, (London: Thames & Hudson, 1995)

Michael Philipp and Ortrud Westheider (eds), *Gerhard Richter: Images of an Era*, (Munich: Hirmer and London: HENI Publishing, 2011)

Francesca Pietropaolo (ed.), *Robert Storr: Interviews on Art*, (London: HENI Publishing, 2017)

Dieter Schwarz and Hans Ulrich Obrist, *Gerhard Richter Books: Writings of the Gerhard Richter Archive Dresden*, (New York: Gregory R. Miller & Co., 2014)

Robert Storr, *Gerhard Richter: October 18, 1977*, (New York: The Museum of Modern Art, 2000)

Robert Storr, *Gerhard Richter: Forty Years of Painting*, (New York: The Museum of Modern Art, 2002)

Robert Storr, *September: A History Painting by Gerhard Richter*, (London: Tate Publishing, 2010)

Artist's Books

Johannes Cladders, *Gerhard Richter: Graue Bilder* (Mönchengladbach: Städtisches Museum Abteiberg, 1974)

Dietmar Elger and Dieter Schwartz, *Gerhard Richter: Elbe: 31 Monotypes*, 1957, (Cologne: Walther König, 1957)

Helmut Friedel, *Gerhard Richter: Atlas* (Cologne: Walther König, 2015)

Hans Ulrich Obrist, *Gerhard Richter: 40 Tage*, (London: HENI Publishing, 2017)

Hans Ulrich Obrist, *Gerhard Richter: OBRIST/O'BRIST*, (Cologne: Walther König, 2009)

Hans Ulrich Obrist (ed.), *Sils*, (Madrid: Ivory Press, 2009)

Sigmar Polke and Gerhard Richter, *Polke/Richter: Richter/Polke*, (Hanover: Galerie h, 1966)

Dieter Schwartz, *Gerhard Richter: November*, (London: HENI Publishing, 2013)

Gerhard Richter: Abstract Painting 825–11, (Zurich: Scalo, 1996)

Gerhard Richter: Birkenau, (Cologne: Walther König, 2016)

Gerhard Richter: Eis, (Cologne: Walther König, 2011)

Gerhard Richter: Night Sketches, (London: HENI Publishing, 2011)

Gerhard Richter: Patterns, (London: HENI Publishing and Cologne: Walter König, 2011)

Gerhard Richter: Sindbad, (Cologne: Walther König, 2010)

Gerhard Richter: Wald, (Cologne: Walther König, 2008)

Gerhard Richter: War Cut, (New York: DAP, 2013)

Gerhard Richter: 128 Details from a Picture (Halifax 1978), (Halifax: The Press of the Nova Scotia College of Art and Design, 1980)

Gerhard Richter: 128 Details from a Picture (Halifax 1978), (Cologne: Walter König, 1998)

Cage Paintings

Frances Guerin, *The Truth is Always Grey: A History of Modernist Painting*, (Minneapolis and London: University of Minnesota Press, 2018)

Robert Storr, *Cage: Six Paintings by Gerhard Richter*, (London: Tate Publishing, 2009)

Cologne Cathedral Window

Hubertus Butin, Stephan Diederichs, Birgit Pelzer and Barbara Schock-Werner, *Gerhard Richter – Zufall: The Cologne Cathedral Window, and 4900 Colours*, (Cologne: Walther König, 2007)

169

Peter Gidal, Hans Ulrich Obrist
and Julia Peyton-Jones, *Gerhard
Richter: 4900 Colours*, (Ostfildern-
Ruit: Hatje Cantz, 2008)

Overpainted Photographs

Achim Borchardt-Hume, Sandra
Dagher and Lamia Joreige,
Gerhard Richter: Beirut, (Beirut:
Beirut Art Center, London: HENI
Publishing and Cologne: Walther
König, 2012)

Dietmar Elger (ed.), *Gerhard
Richter: Firenze*, (Ostfildern-
Ruit: Hatje Cantz, 2001)

Markus Heinzelmann (ed.),
*Gerhard Richter: Overpainted
Photographs*, (Ostfildern-Ruit:
Hatje Cantz, 2008)

Hans Ulrich Obrist and Gerhard
Richter, *Gerhard Richter: Sils*,
(New York: DAP, 2002)

Bruno Corà and Enzo
Restagno, *Gerhard Richter: City
Life*, (Prato: Gli Ori, 2002)

Architecture

Jean-Louis Cohen and Hartmut
Frank, *Interférences/Interferenzen:
Architecture Allemagne-France
1800–2000*, (Strasbourg: Editions
des Musées de Strasbourg, 2013)

Michael Mack (ed.),
*Reconstructing Space:
Architecture in Recent German
Photography*, (London:
Architectural Association
Publications, 1999)

Susan Tallman and Peter
Noever (eds), *Silent & Violent:
Selected Artists' Editions*,
(Zurich: Parkett, 1995)

All artwork titles are given in English.

Translation from German to English of 'Nothing Works Without
Faith', 'Like Bright Dust and Fog' and 'A Distorted Form of Legibility'
by Helen Ferguson.

Cover of *Snow-White* p.128 © Wako Works of Art, Tokyo, Japan
Cover of *...dontstopdontstop...* p.133 © Gerhard Richter and
Hans Ulrich Obrist
Cover of *Night Sketches* p.140 © HENI Publishing

Photography:
Cover image © Sabine Moritz-Richter
pp.8, 36, 44, 64, 84, 96, 148, 164 © Joe Hage
Cologne Cathedral Window p.77 © HENI, courtesy Chris Gascoigne
All other images © Gerhard Richter 2019

ISBN 978-1-9121222-4-0

A catalog record for this book is available
from The British Library.

Designed by Andy McGarity with help from Sylvia Ugga
Cover designed by Sylvia Ugga
Edited by Phoebe Adler and Andrew Brown
Proofread by John Jervis
Printed by Graphius in Belgium
Typeset in FF Bau